Michigan

impressions

Photography by Darryl R. Beers

FARCOUNTRY
PRESS

RIGHT: Opened for traffic on November 1, 1957, the 5-mile-long Mackinac Bridge connects the Upper and Lower Peninsulas of Michigan and spans the Straits of Mackinac, where Lake Michigan and Lake Huron meet.

TITLE PAGE: Sunrise casts soft light on sailboats in Lake Huron's Alpena Harbor.

FRONT COVER: Located on the northern shore of the Keweenaw Peninsula, the Eagle Harbor Lighthouse overlooks Lake Superior.

BACK COVER: Sailboats line the docks in Lake Superior's Marquette Harbor.

ISBN 10: 1-56037-385-7
ISBN 13: 978-1-56037-385-8
Photography © 2006 Darryl R. Beers
© 2006 Farcountry Press

For more information about our books write Farcountry Press, P.O. Box 5630, Helena, MT 59604; call (800) 821-3874; or visit www.farcountrypress.com.

Created, produced, and designed in the United States.
Printed in China.

10 09 08 07 06 1 2 3 4 5

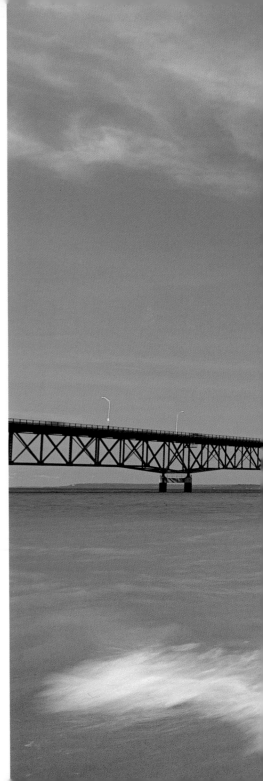

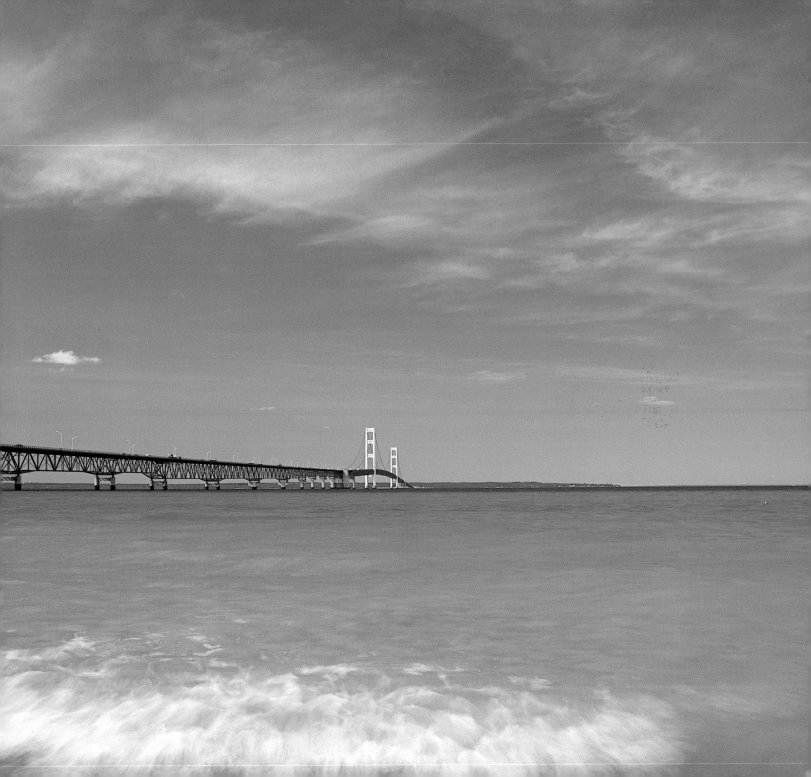

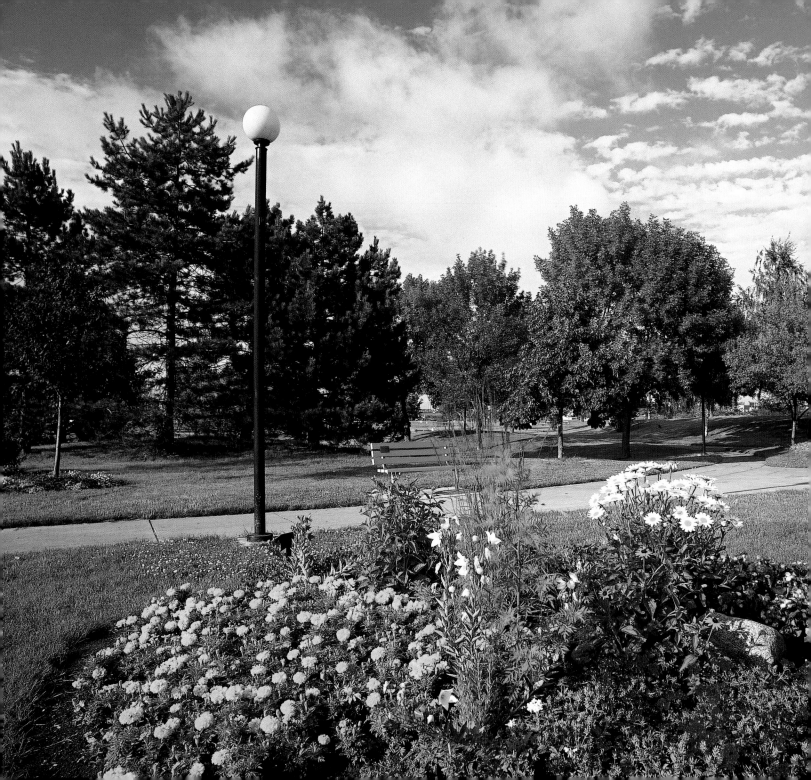

LEFT: Paths meander through the Kantzler Memorial Arboretum, part of The Gardens at Riverwalk along the west bank of the Saginaw River in downtown Bay City.

BELOW LEFT: Purple milkweed grows in 8,000-acre Wilderness State Park along the shore of Lake Michigan.

BELOW RIGHT: Roses drape a fence in the town of East Tawas.

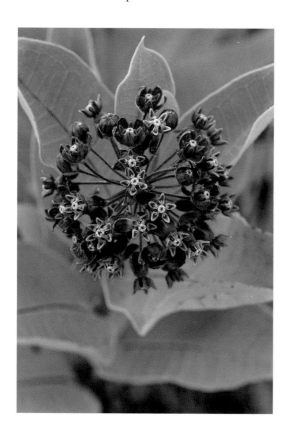

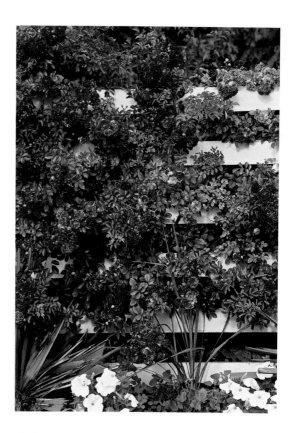

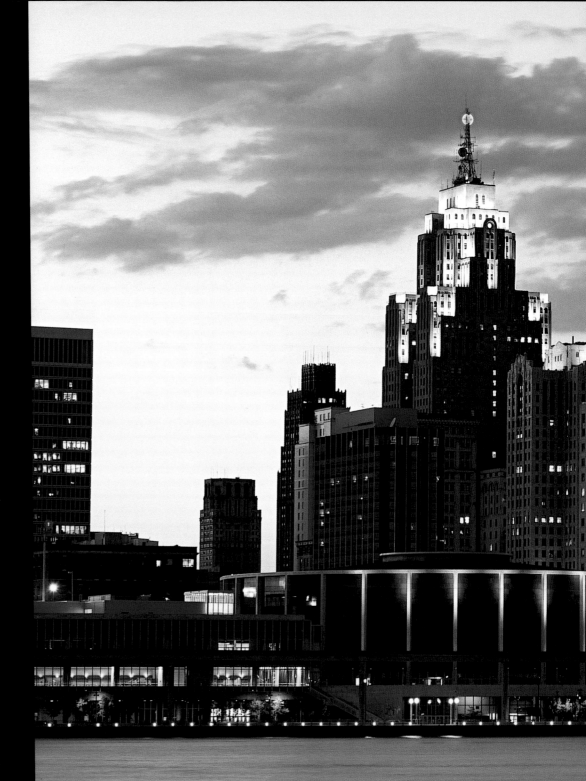

The city of Detroit, on the
Detroit River, has come a
long way since it was estab-
lished in 1701 as a fort and
settlement by French
officer Antoine de la
Mothe, Sieur de Cadillac.

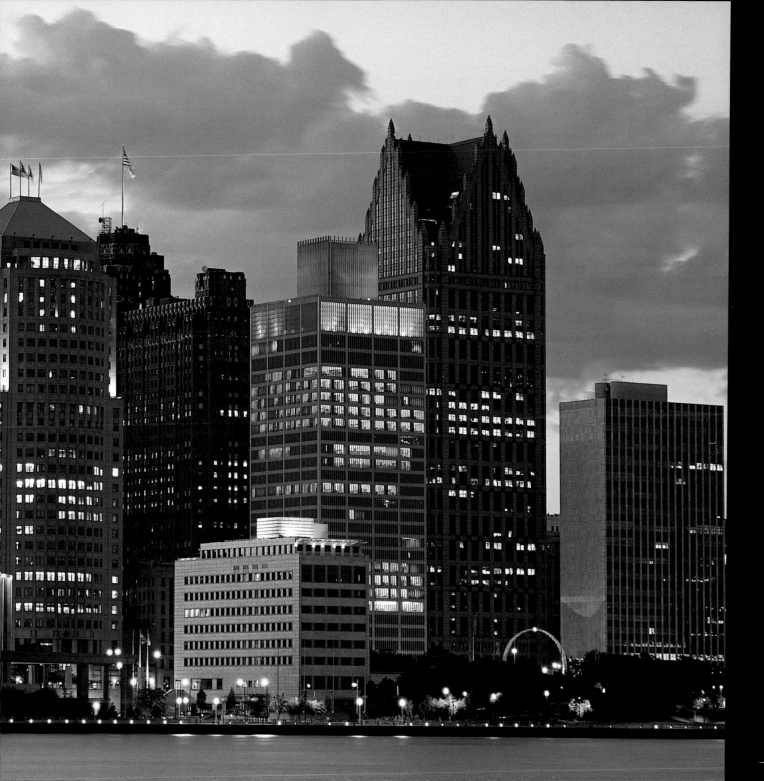

RIGHT: Bulldog Creek flows south from McDonald Lake in Schoolcraft County to Lake Michigan.

BELOW: Ice floes move through Lake Superior near Marquette.

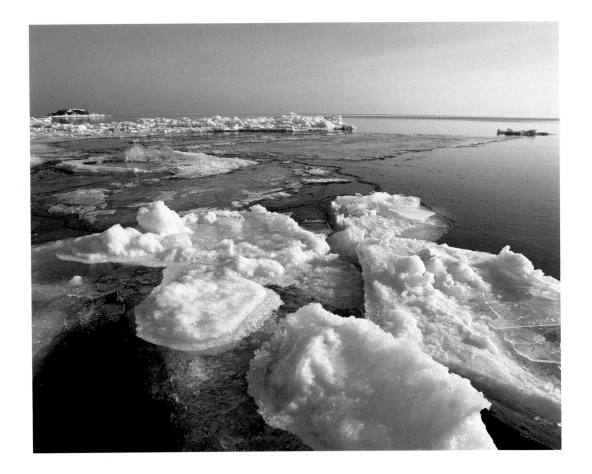

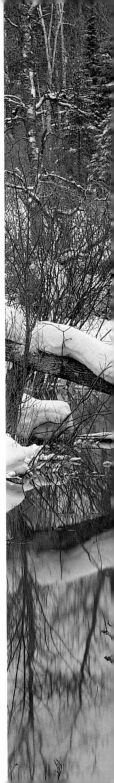

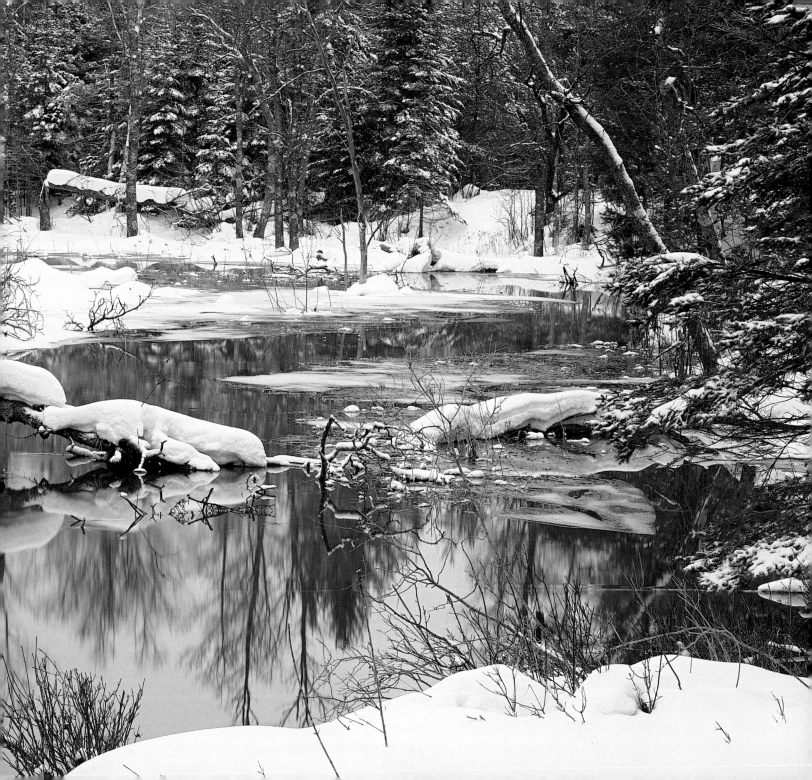

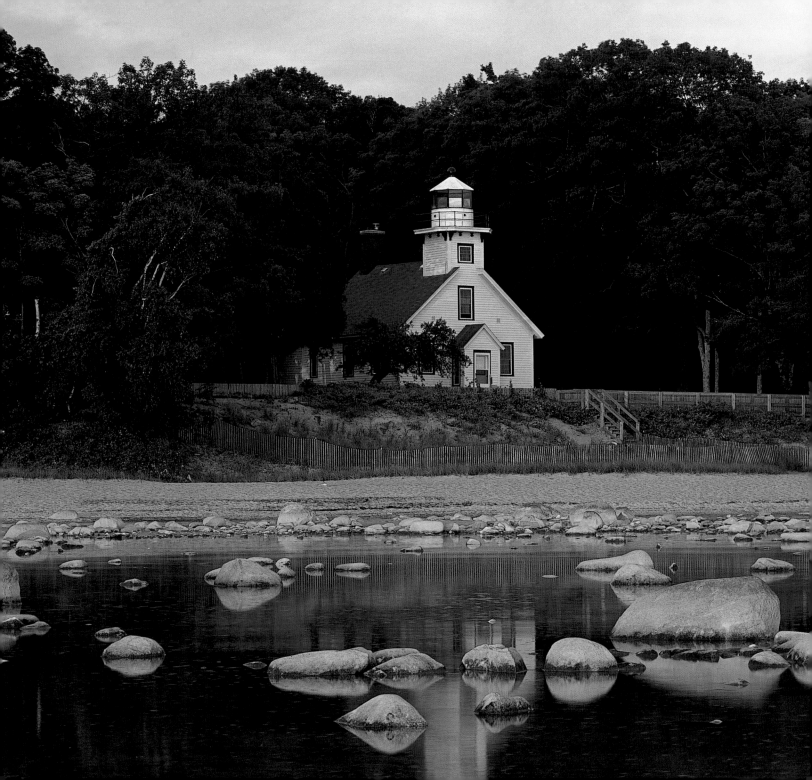

LEFT: Located in Peninsula Township Park, the Old Mission Point Lighthouse on Lake Michigan first displayed its light in 1870. The lighthouse is no longer in use but serves as a residence for park employees.

BELOW: A pastel sunrise is reflected on Lake Huron's Thunder Bay.

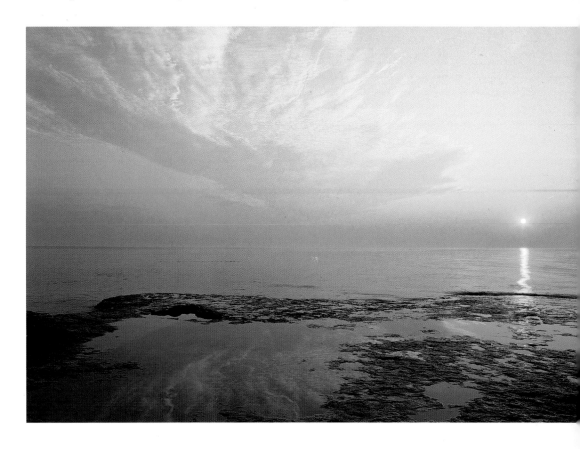

RIGHT: The centerpiece of the Pictured Rocks National Lakeshore, the "pictured rocks" are 300-foot-tall sandstone bluffs that extend 7 miles along Lake Superior from Miners Castle to the Grand Portal. Erosion has sculpted the bluffs into whimsical shapes.

BELOW: Dedicated in 1919, William Mitchell State Park occupies 334 acres between Lake Mitchell and Lake Cadillac. A historic quarter-mile canal runs through the park and connects the two lakes.

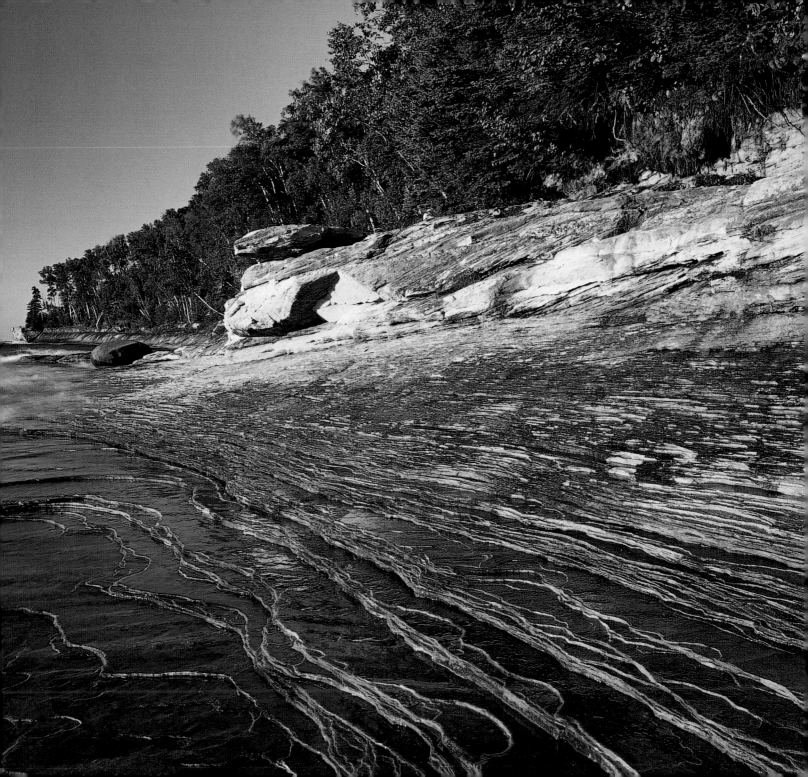

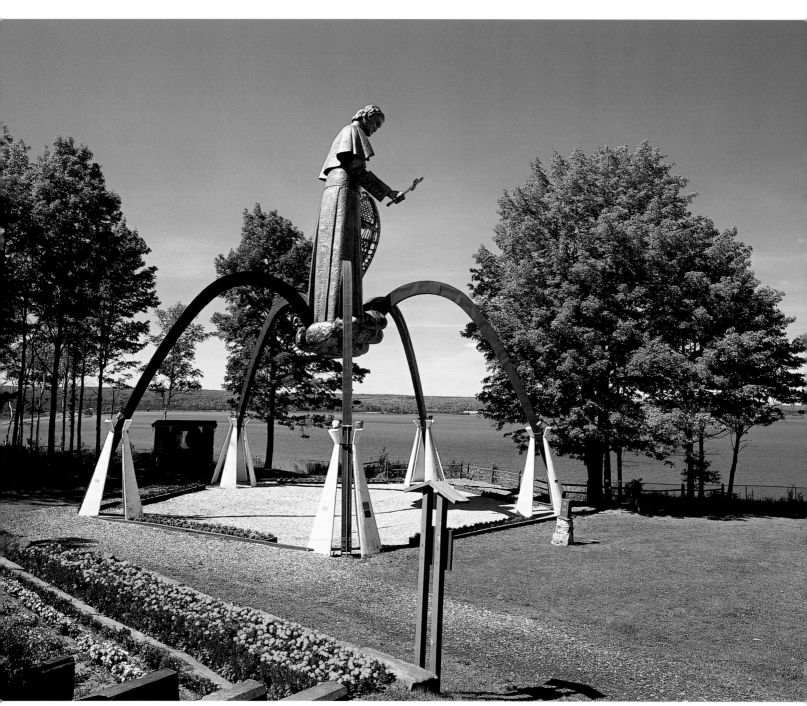

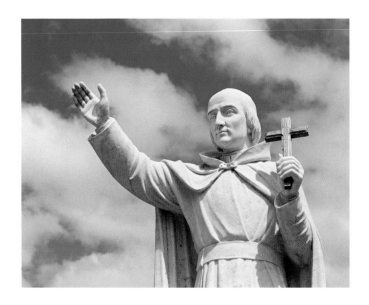

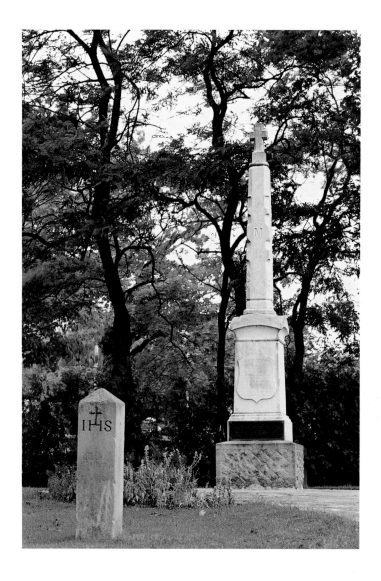

ABOVE: This statue in Father Marquette Mission Park honors the life and work of French priest and explorer Jacques Marquette, who founded a Jesuit mission in the St. Ignace area in 1671.

RIGHT: Father Marquette died in 1675 and is buried in Father Marquette Mission Park in downtown St. Ignace.

FACING PAGE: This statue of Bishop Frederic Baraga atop a cloud is supported by five small tepees and overlooks Keweenaw Bay. Bishop Baraga holds a cross and a pair of snowshoes—he was known as the "Snowshoe Priest" because he always wore snowshoes when traveling between missions in winter.

RIGHT: A vivid sunrise is reflected in Lake Superior's Tobin Harbor in Isle Royale National Park.

BELOW: Wood lilies are found in Michigan's dry woods and thickets.

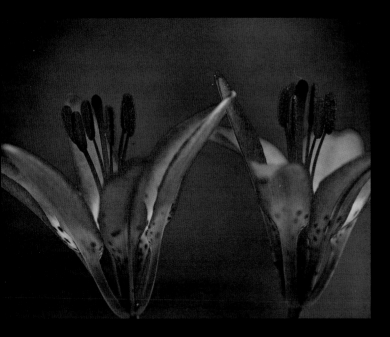

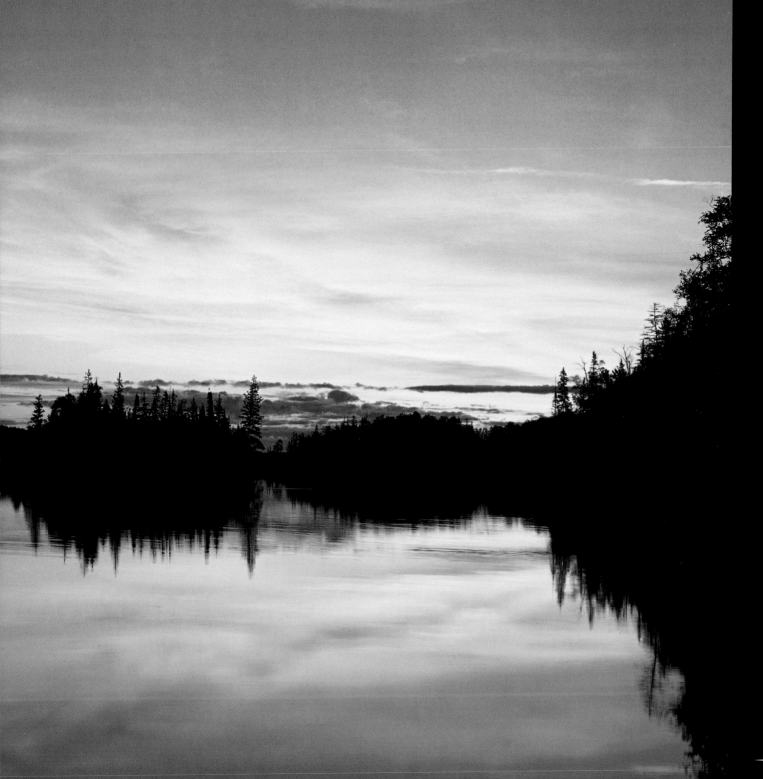

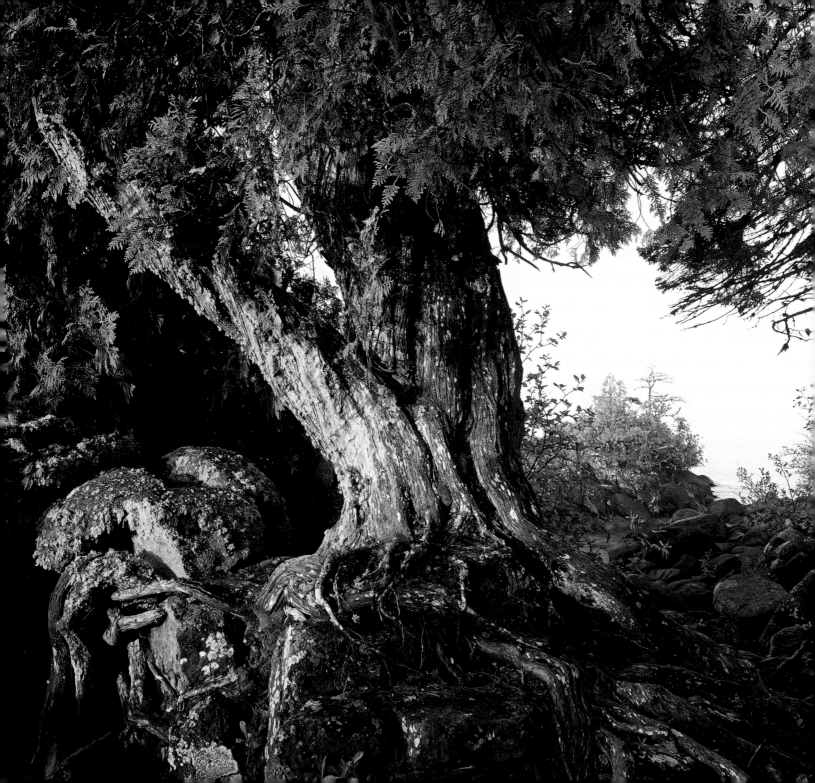

LEFT: A white cedar grips the rocky shore of Lake Superior in Isle Royale National Park.

BELOW: Sleepy Hollow State Park, north of Lansing, is known for its diversity of bird species, from waterfowl to raptors.

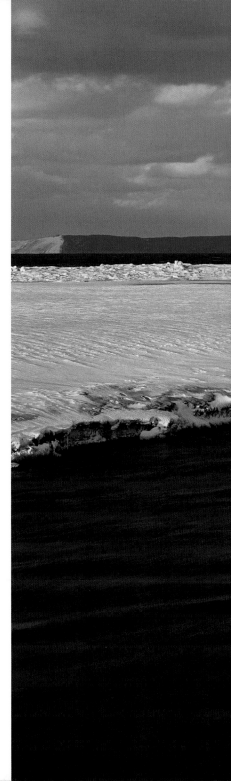

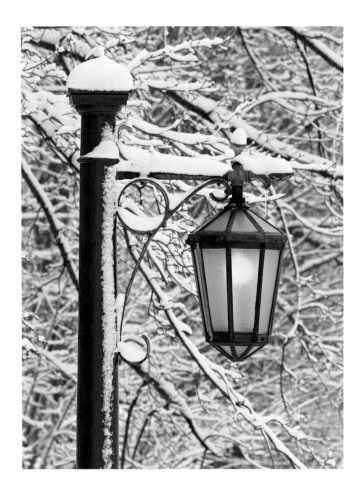

ABOVE: Fresh snow collects on an old-fashioned streetlight in Hancock, which receives an average annual snowfall of 20 feet.

RIGHT: The Platte River empties into Lake Michigan at Sleeping Bear Dunes National Lakeshore, which encompasses 35 miles of coastline and North and South Manitou Islands.

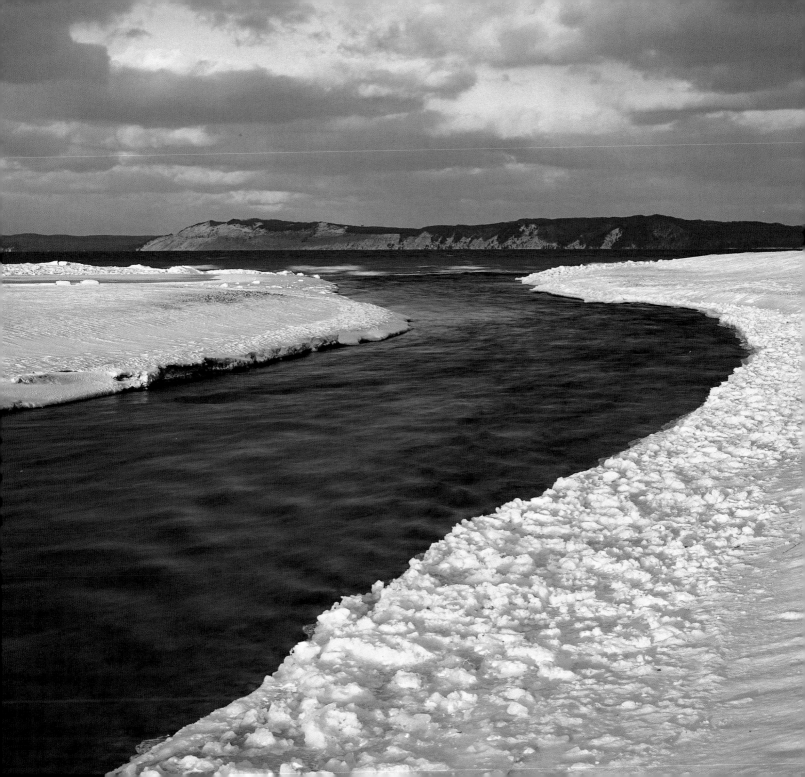

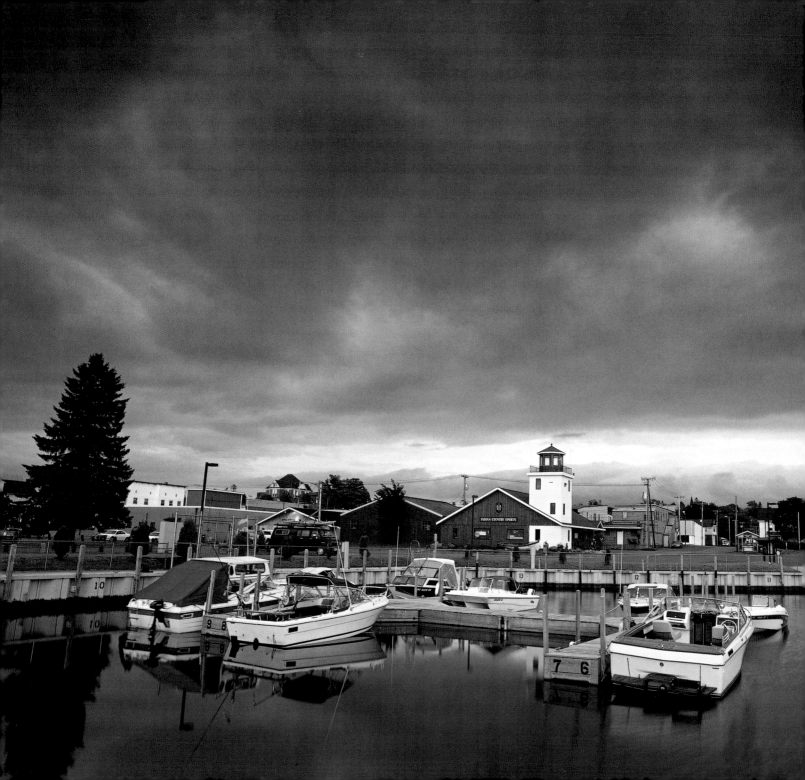

LEFT: L'Anse is a waterfront community on Lake Superior's Keweenaw Bay.

BELOW: Sunset silhouettes a retired anchor displayed by the shore in L'Anse.

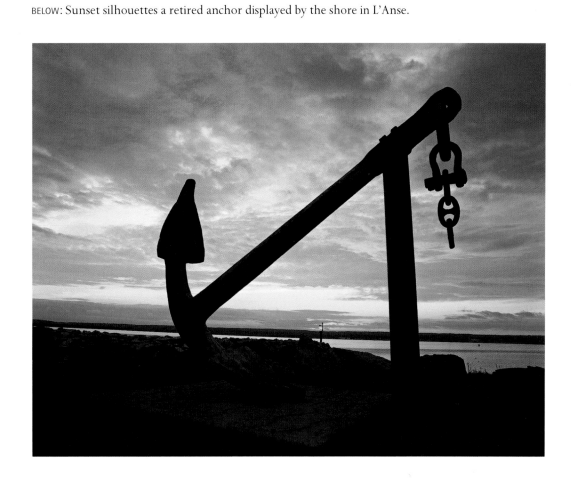

RIGHT: Deep in Copper Country State Forest is picturesque Hungarian Falls.

BELOW: An angler ventures out onto a log in the Tahquamenon River in hopes of bringing home the catch of the day. The river meanders through Tahquamenon Falls State Park, which, at more than 40,000 acres, is Michigan's second largest state park. The river's Upper Falls, which is 200 feet across and drops 50 feet, is one of the largest waterfalls east of the Mississippi.

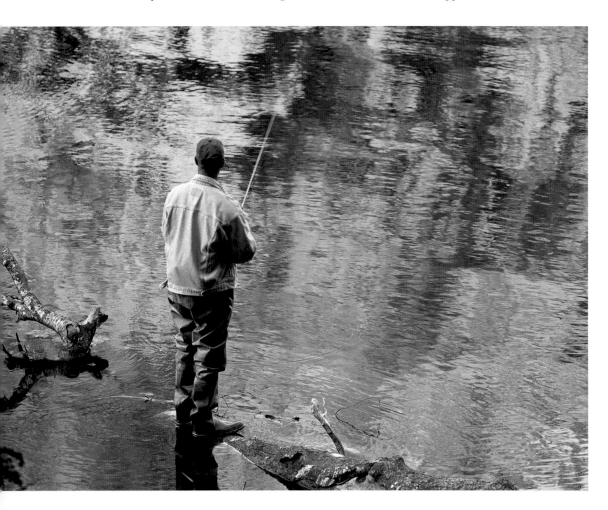

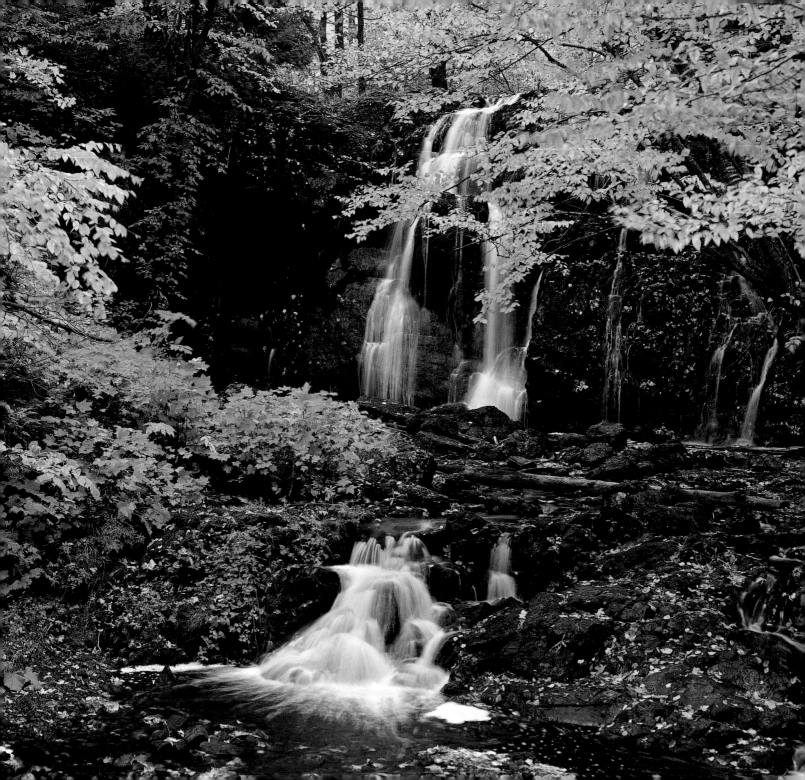

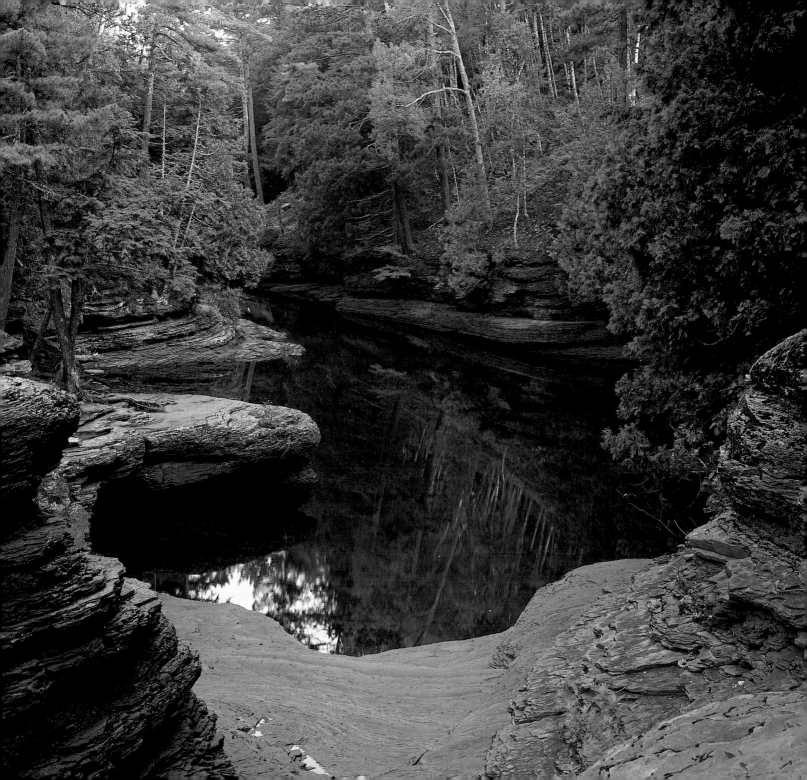

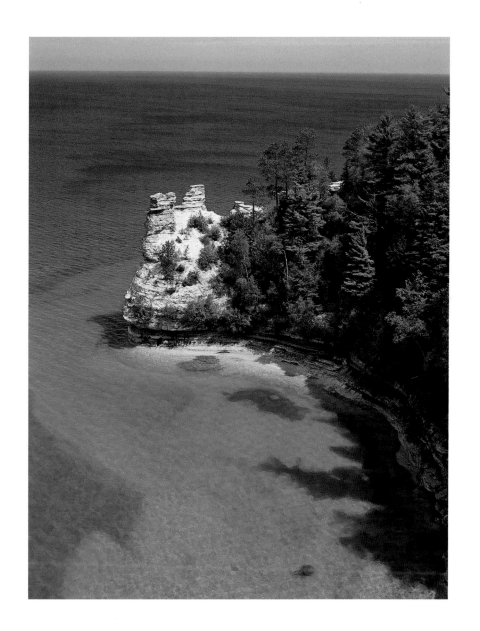

LEFT: The sandstone cliffs of Miners Castle overlook the verdant waters of Lake Superior at Pictured Rocks National Lakeshore.

FAR LEFT: The waters of the Presque Isle River turn glassy in this shady slough in Porcupine Mountains Wilderness State Park.

RIGHT: Now part of Windmill Island, the eighteenth-century DeZwaan Windmill was a gift from the Netherlands to the city of Holland, Michigan. More than 6 million tulips bloom in the Holland area in spring.

BELOW: The butter-colored blossoms of common toadflax brighten the Michigan countryside.

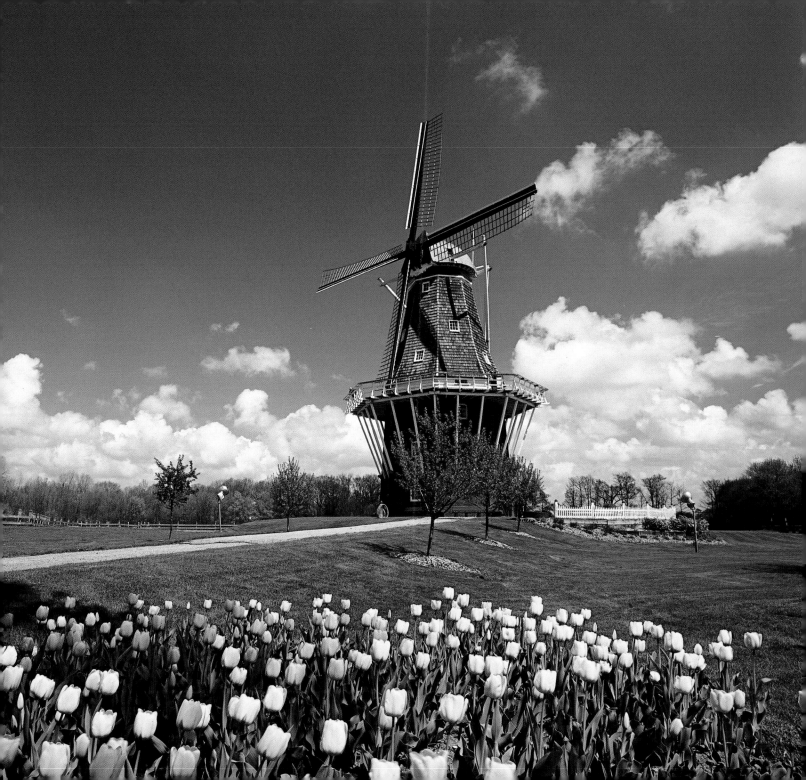

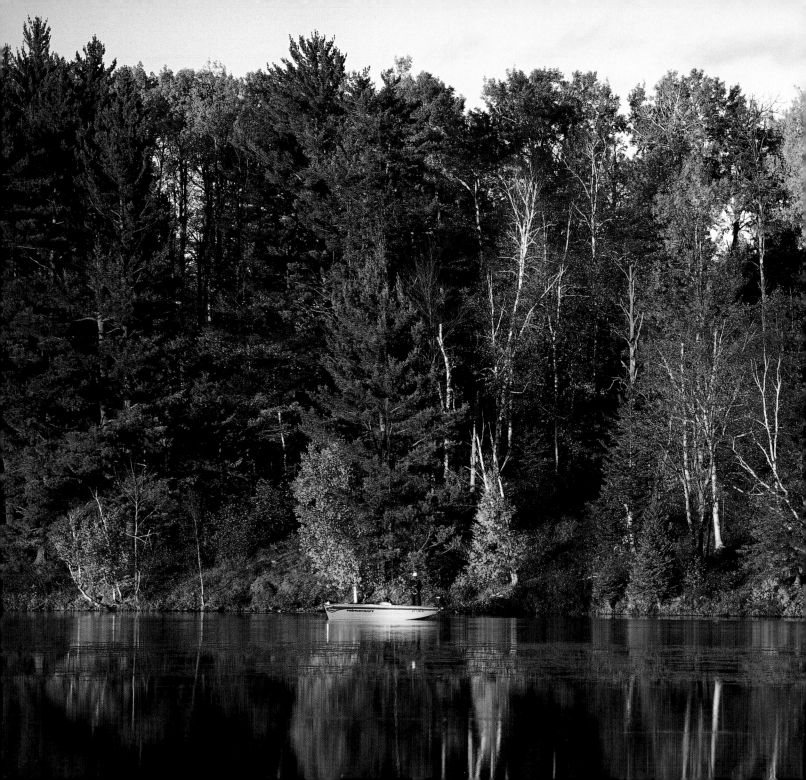

LEFT: An angler enjoys a glorious fall evening on the Paint River Pond in Iron County.

BELOW: Highbush blueberry, red with the arrival of autumn, carpets the woods in South Higgins Lake State Park.

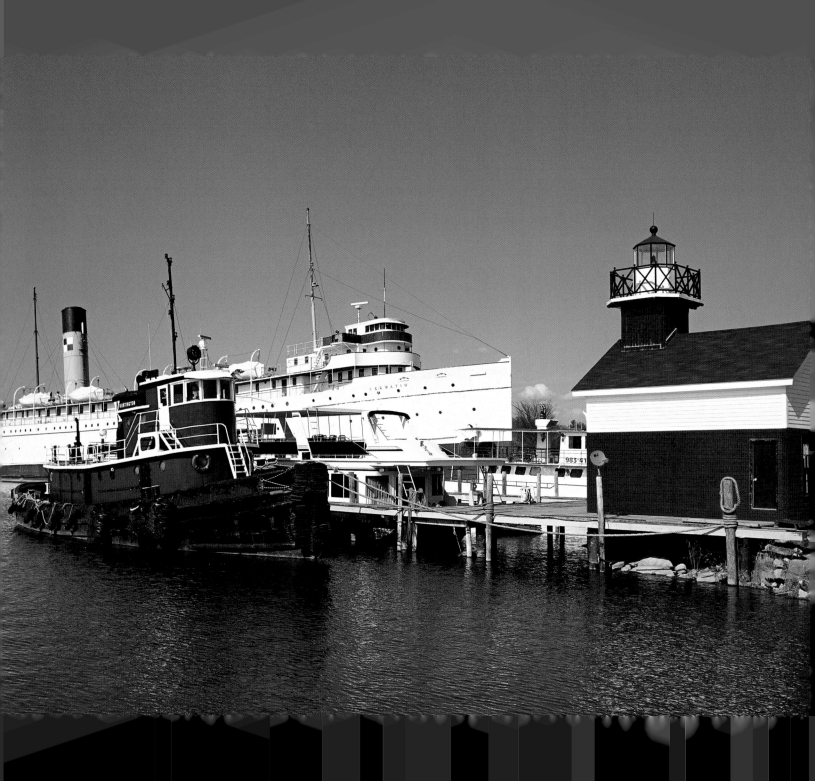

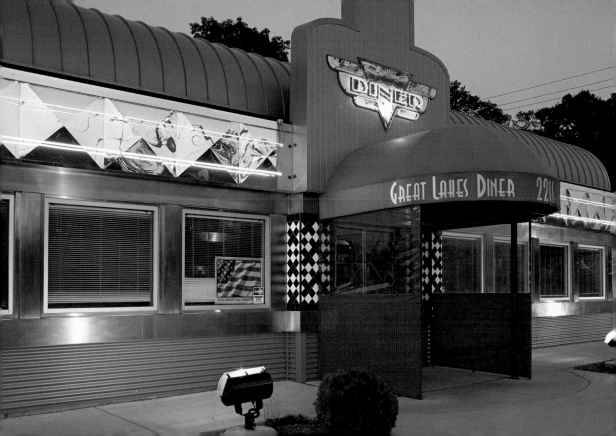

RIGHT: The Grand
River courses more
than 260 miles
through the state
to Lake Michigan.
This segment flows
through Chief Hazy
Cloud County Park
near Grand Rapids.

FAR RIGHT: Located
primarily in
Hiawatha National
Forest, the Sturgeon
River is considered
a Michigan Blue
Ribbon Trout
Stream for its
excellent fishing.

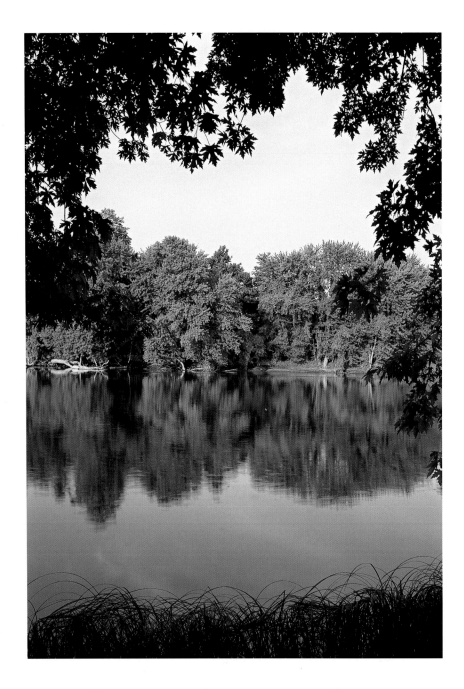

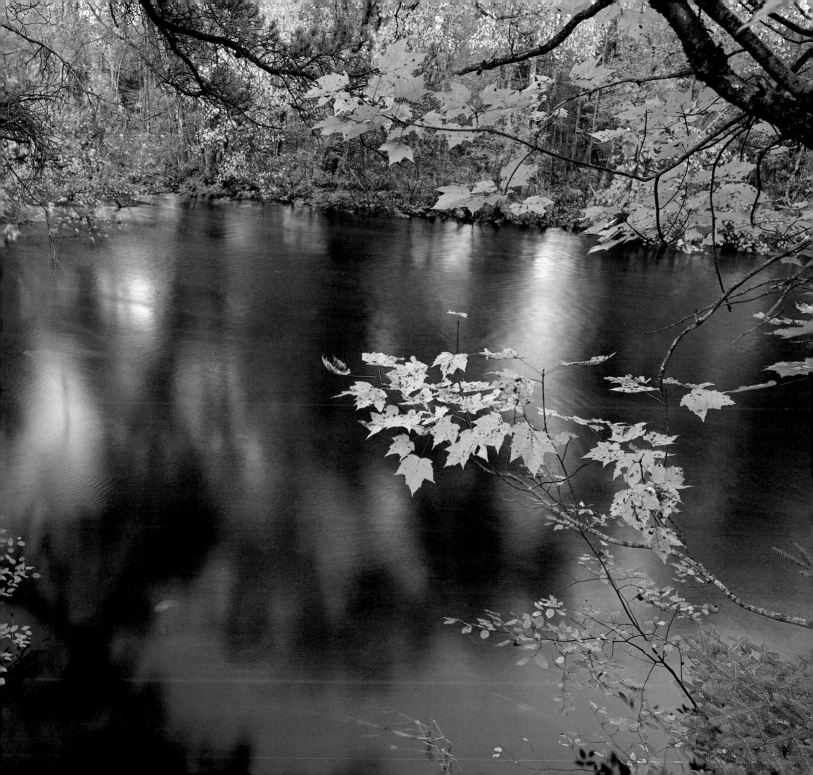

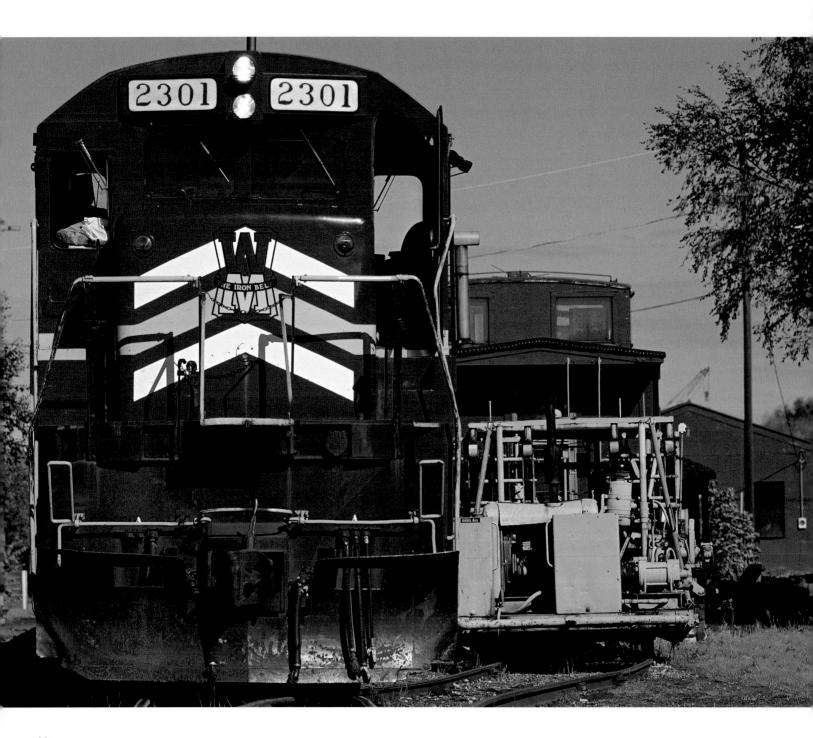

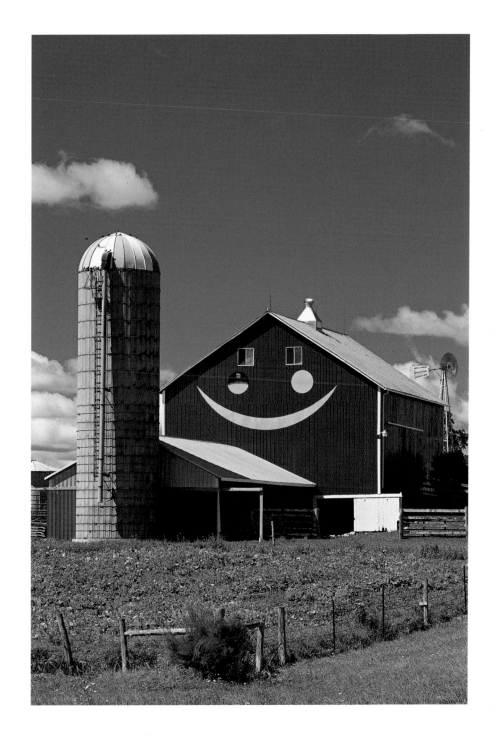

LEFT: A wink and smile on this Alpena County barn greet passersby.

FACING PAGE: Wisconsin–Michigan Railroad Engine No. 2301 pulls into the Ironwood rail yard.

RIGHT: The scenic Piers Gorge is a fast-moving stretch of the Menominee River, which marks the border between Michigan's Upper Peninsula and Wisconsin.

BELOW: The ivory flowers of the musk mallow grace many of Michigan's meadows.

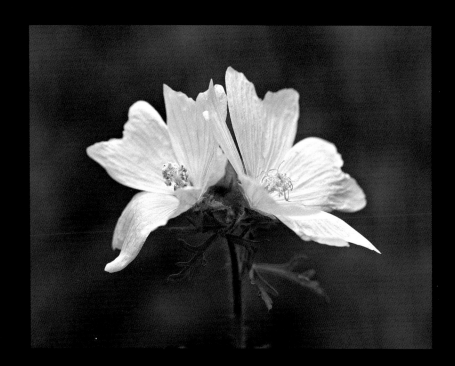

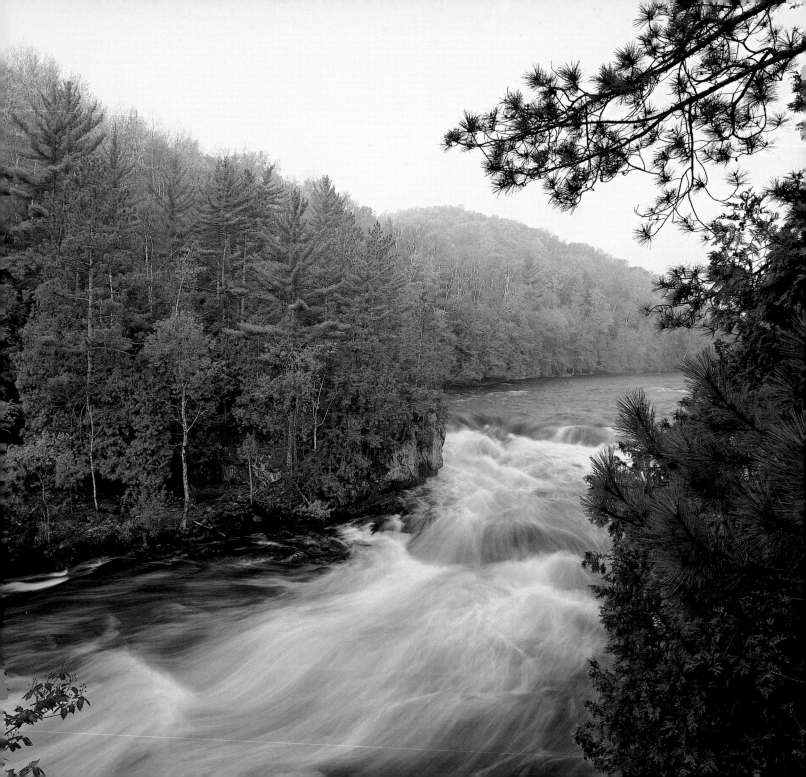

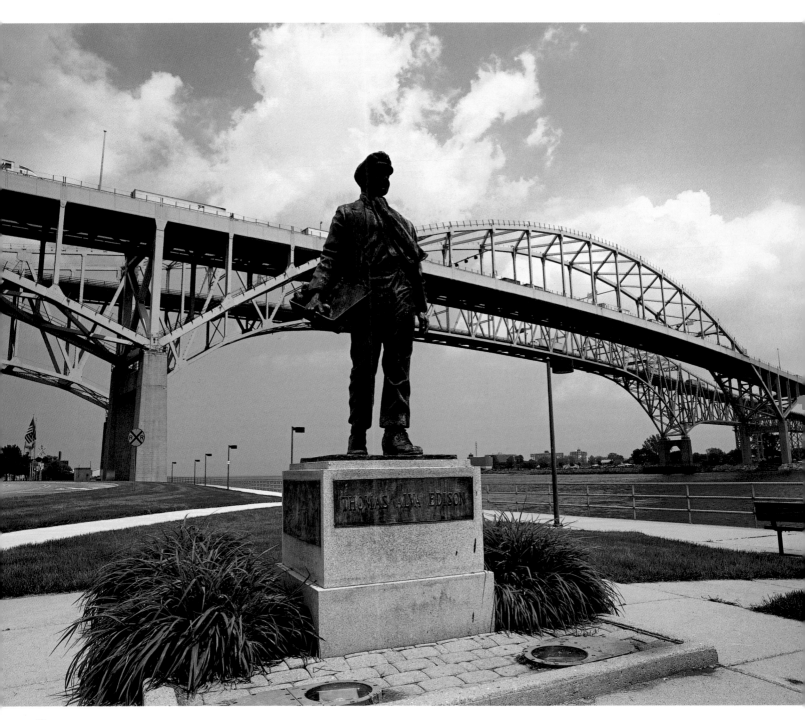

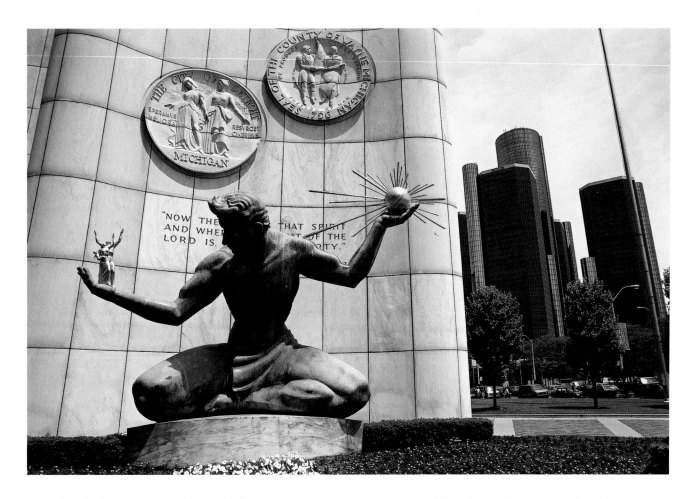

ABOVE: This 16-foot statue entitled *Spirit of Detroit* stands beside the city–county building. Created by sculptor Marshall Fredericks, the statue represents the relationship between God and humanity. The figure's left hand holds an orb, Fredericks' conception of God. In the figure's right hand are small figures representing a family. PHOTO BY DENNIS COX

FACING PAGE: A statue in honor of Thomas Alva Edison is exhibited near the Thomas Edison Depot Museum and the Blue Water International Bridge, which connects Port Huron, Michigan, and Sarnia, Ontario. Edison spent his early years in Port Huron and worked on the Grand Trunk Railroad.

RIGHT: Water flows over the plastic roof and cascades down the open sides of this unique outdoor art installation at the corner of Grand River and Washington Boulevard in Detroit. The roof shelters tables where downtown workers can enjoy an outdoor lunch break.

FACING PAGE: Two large tiger statues stand above the entrance to Comerica Park, home of Major League Baseball's Detroit Tigers.

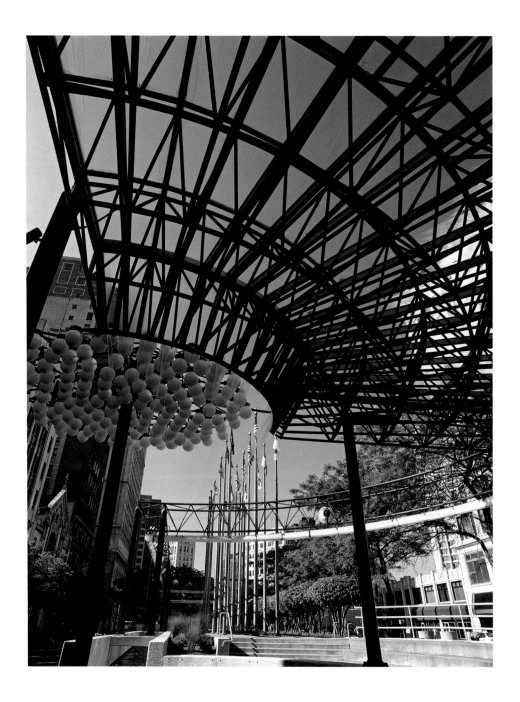

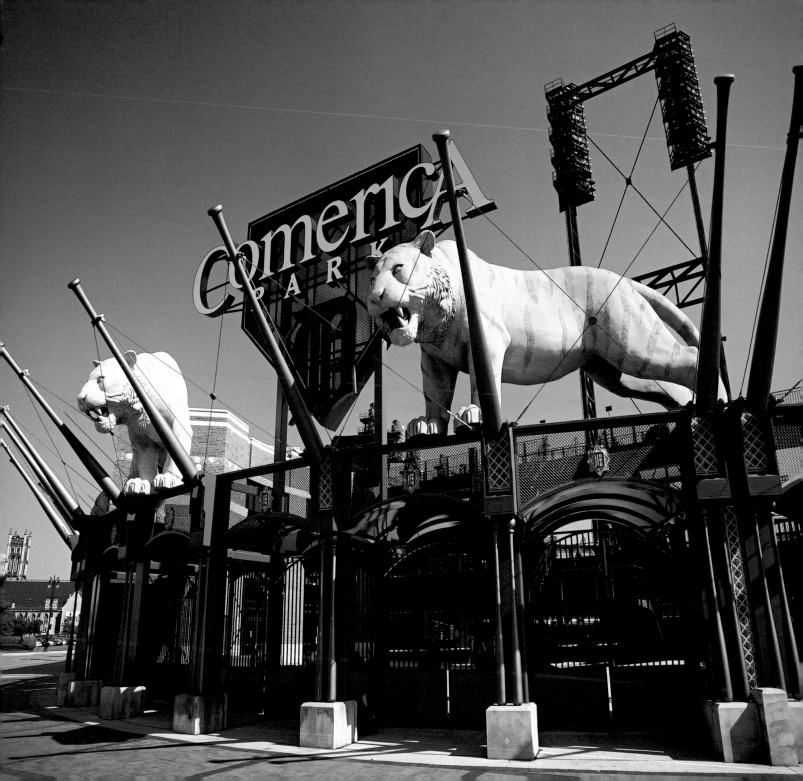

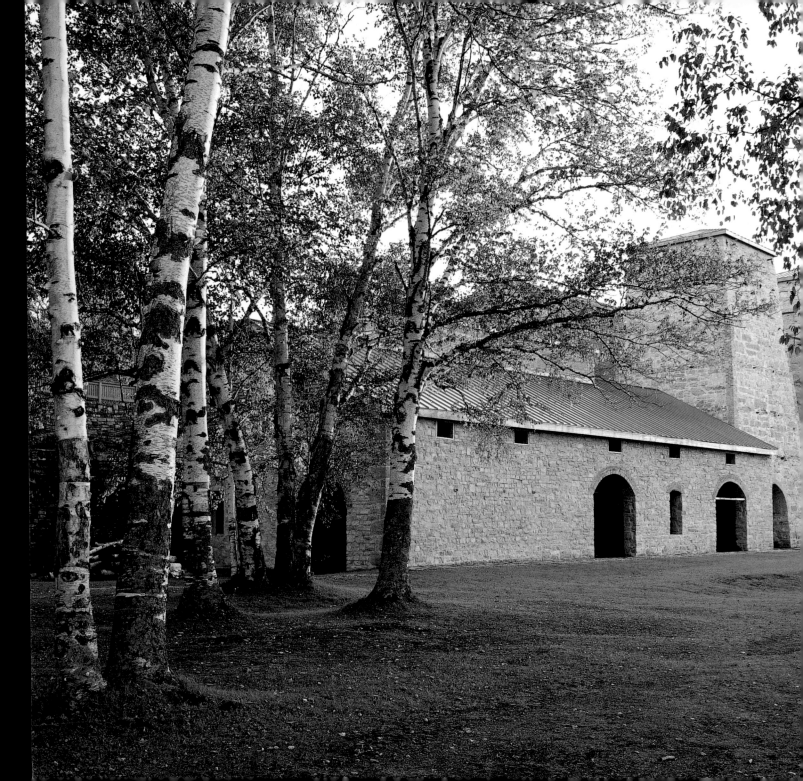

LEFT: Visitors can tour these 1880s iron smelters in the ghost town of Fayette in Fayette State Park. Poplar and maple trees were burned to make charcoal, and the heat of the charcoal removed the iron ore from the rock. One-hundred-pound chunks of iron, called pigs, were then shipped to sites for industrial use.

BELOW: Bigtooth aspen trees show off their fall foliage in Au Sable State Forest.

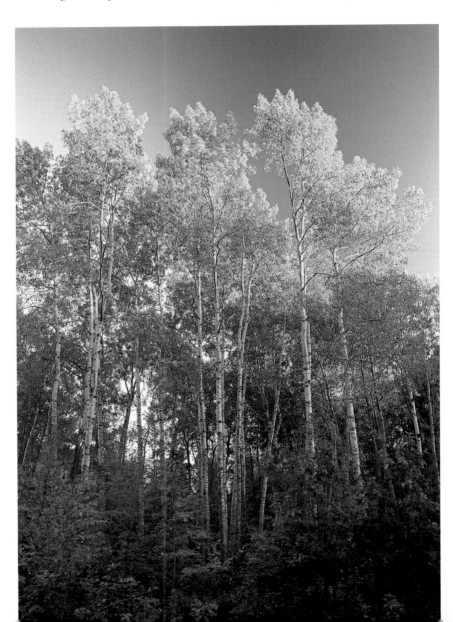

RIGHT: The De Tour Reef Light is a 74-foot-tall lighthouse located one mile offshore at the entrance to the St. Mary's River, which connects Lake Superior and Lake Huron. The light has been in operation at the location since 1931.

FAR RIGHT: The freighter *Algosteel* moves through the Soo Locks in Sault Ste. Marie, the third oldest continuous settlement in the United States. The Soo Locks allow ships traveling between Lake Superior and Lake Huron to bypass the rapids on the St. Mary's River.

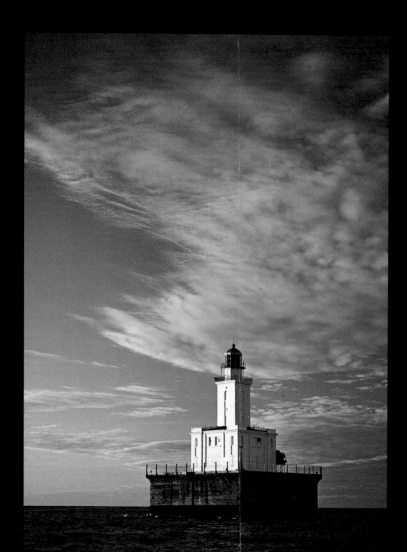

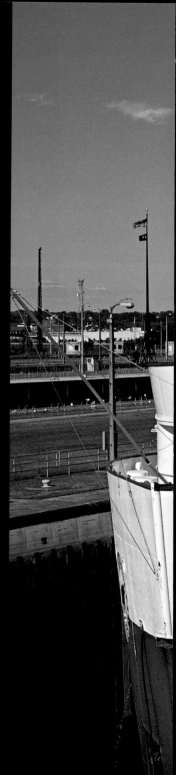

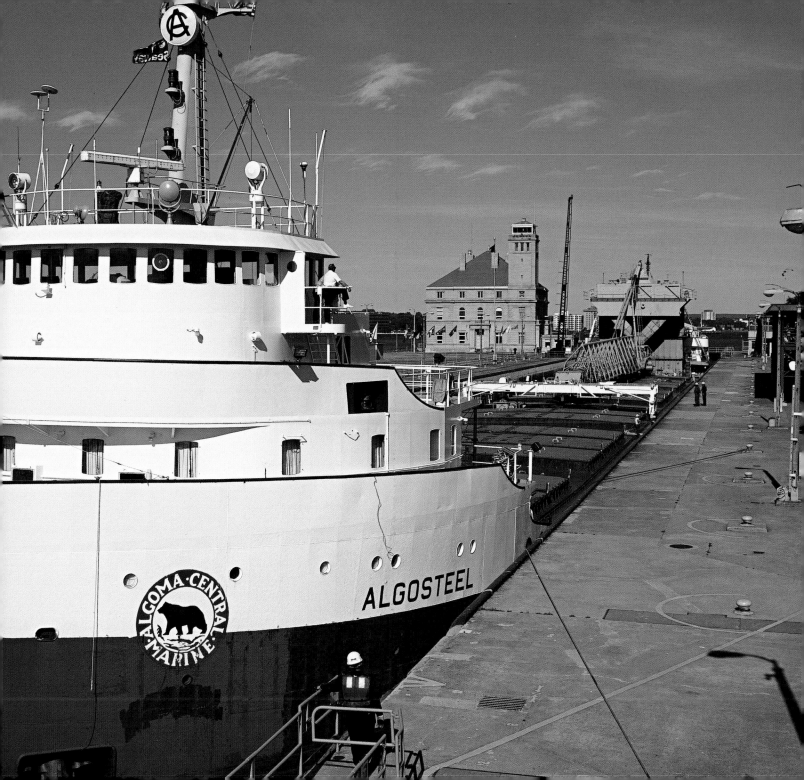

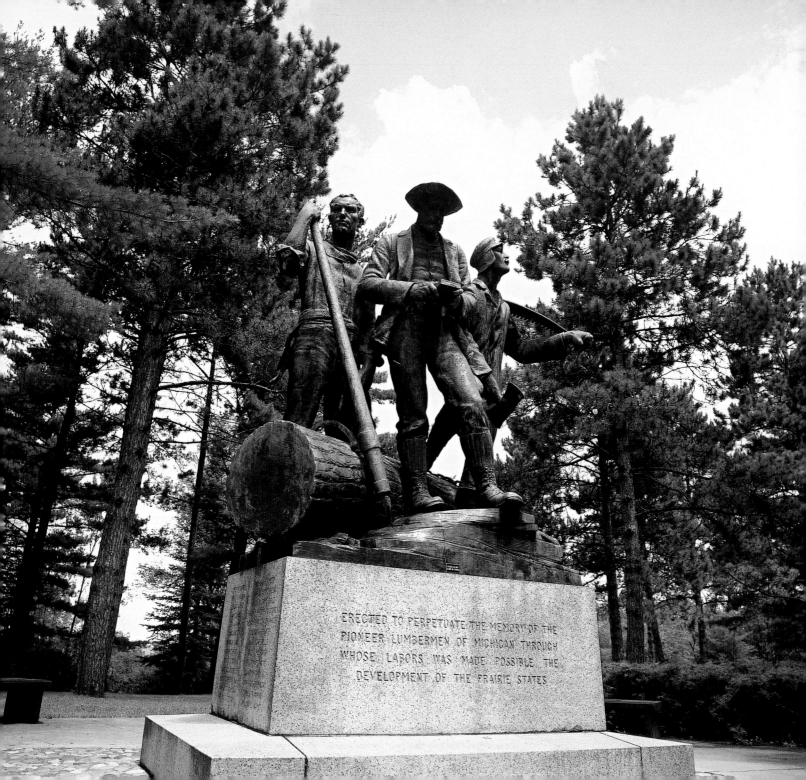

ERECTED TO PERPETUATE THE MEMORY OF THE
PIONEER LUMBERMEN OF MICHIGAN THROUGH
WHOSE LABORS WAS MADE POSSIBLE THE
DEVELOPMENT OF THE PRAIRIE STATES

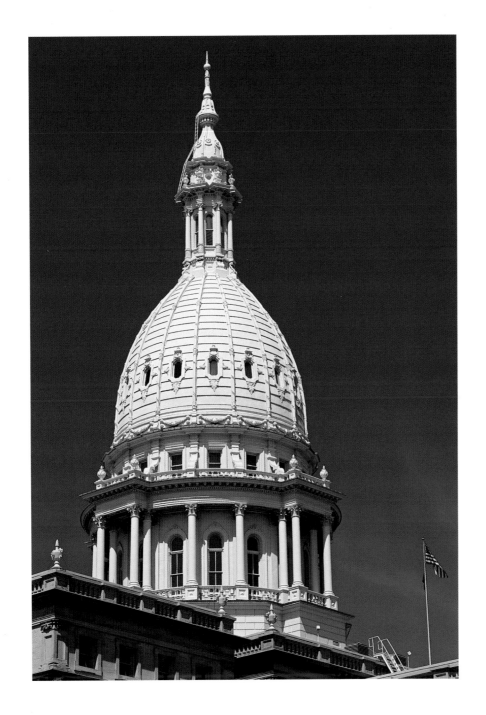

LEFT: Completed in 1879, the Michigan state capitol was designed by Elijah E. Myers. The dome comprises four floors and is 44 feet in diameter at its widest point.

FACING PAGE: The 14-foot-tall Lumberman's Monument was created in 1931 to honor the lumbermen who harvested Michigan's giant white pines—the official state tree—in the 1800s. The Lumberman's Monument Visitor Center is located near Oscoda, and the bronze statue overlooks the Au Sable River.

FACING PAGE: Built in 1888, this building once housed the Flint Road Cart Company. One of the company's co-founders, William C. Durant, later formed General Motors in 1908.

BELOW: Kids cool off outside Oldsmobile Park in Lansing. The park is home of the Class A Midwest League Lansing Lugnuts and hosts festivals and concerts.

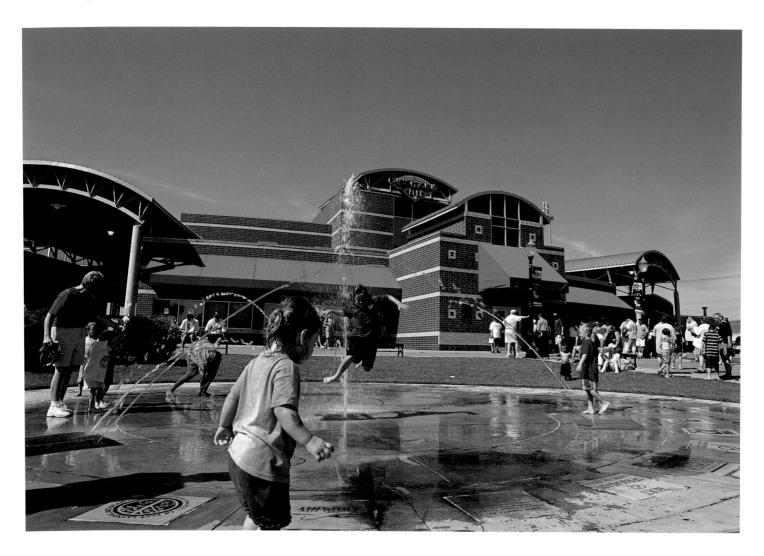

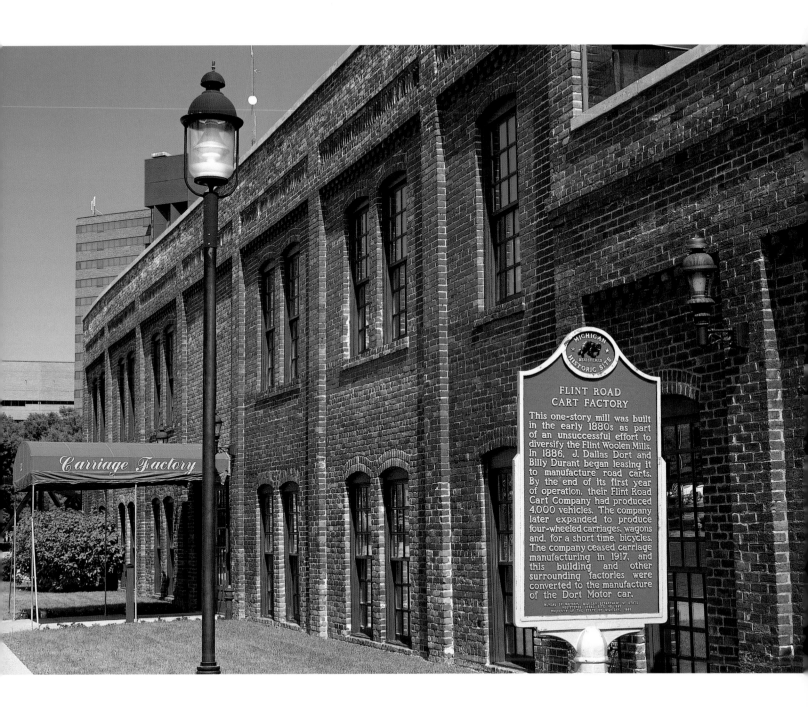

FLINT ROAD CART FACTORY

This one-story mill was built in the early 1880s as part of an unsuccessful effort to diversify the Flint Woolen Mills. In 1886, J. Dallas Dort and Billy Durant began leasing it to manufacture road carts. By the end of its first year of operation, their Flint Road Cart Company had produced 4,000 vehicles. The company later expanded to produce four-wheeled carriages, wagons and, for a short time, bicycles. The company ceased carriage manufacturing in 1917, and this building and other surrounding factories were converted to the manufacture of the Dort Motor car.

BUREAU OF HISTORY, MICHIGAN DEPARTMENT OF STATE
REGISTERED LOCAL SITE NO. 149
PROPERTY OF THE STATE OF MICHIGAN, 1985

MICHIGAN REGISTERED HISTORIC SITE

Carriage Factory

RIGHT: A flowering vine clings to the trees in Pinckney State Recreation Area in Washtenaw County.

FAR RIGHT: The Chesaning Showboat has presented vaudeville-style shows on the Shiawassee River since 1937.

FACING PAGE: Built in 1914 for $305,000, the stately city hall building in Battle Creek is listed on the National Register of Historic Places.

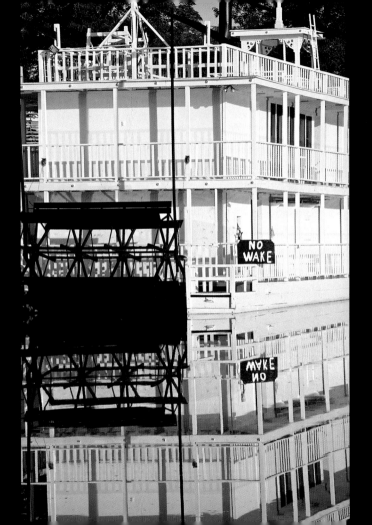

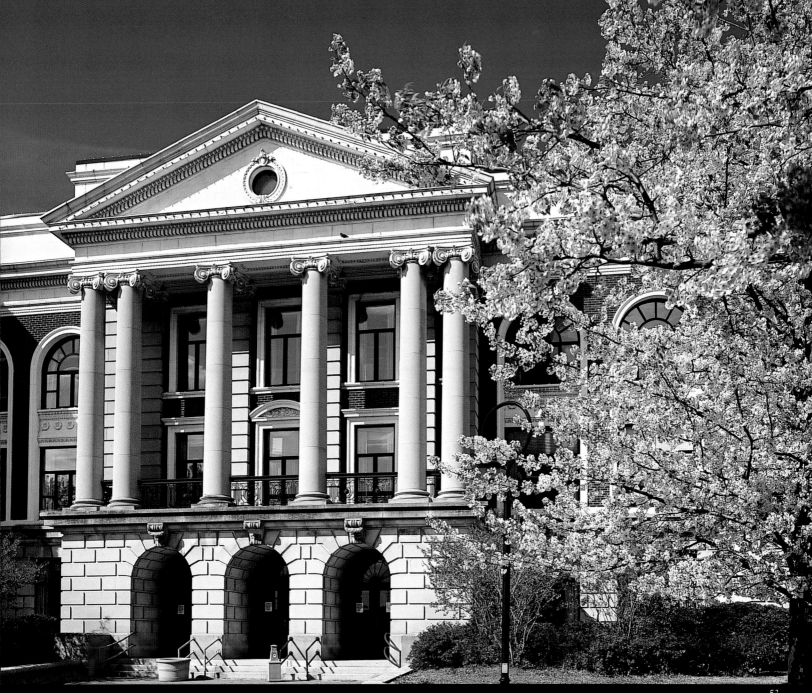

FACING PAGE: Built in 1858, St. Mary's Church served the early mining community of Cliff. In 1899 the church was dismantled and rebuilt in Phoenix, Michigan.

BELOW: Winter has arrived at this wooded pond in Hiawatha National Forest.

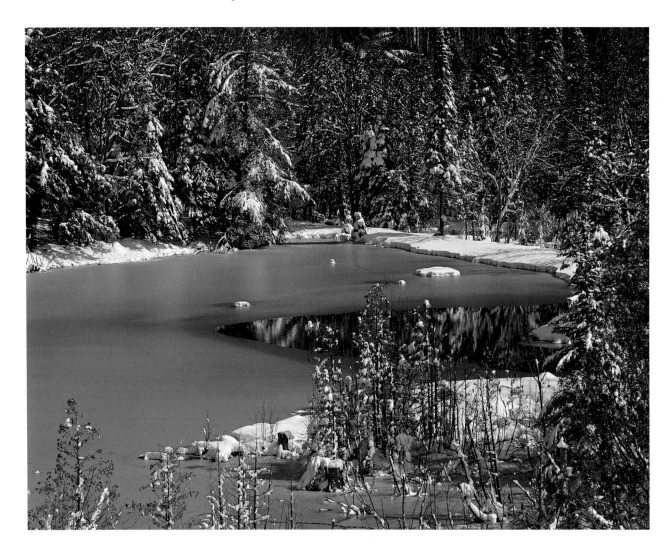

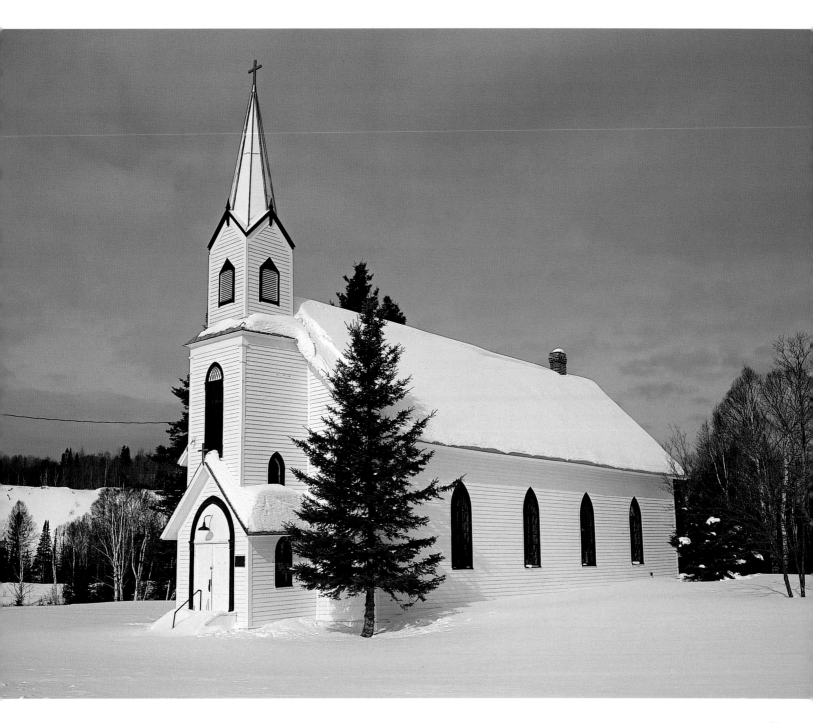

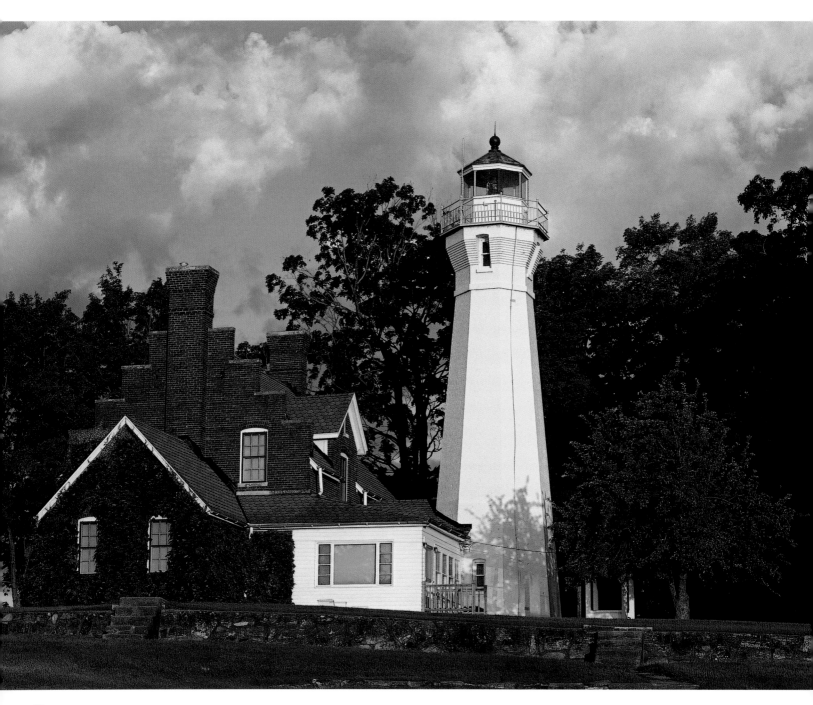

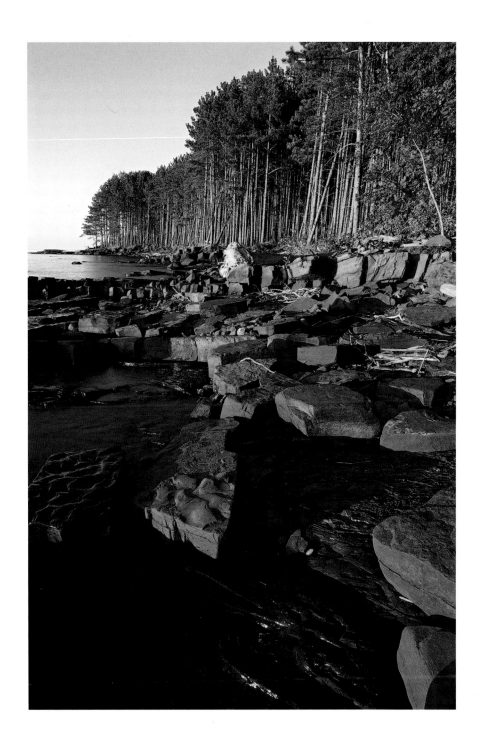

LEFT: Sun sets on the rocky shore of Lake Superior near Gull Point in Ontonagon County.

FACING PAGE: Built in 1886, the Port Sanilac Lighthouse on Lake Huron originally burned kerosene; the lighthouse was electrified in 1929.

RIGHT: Soybeans are a popular crop in Michigan and are grown primarily in the southern part of the state's Lower Peninsula. This thriving field is located in Sanilac County.

BELOW: Grapes hang heavy on the vine in Michigan wine country. With approximately 13,500 acres of vineyards, Michigan is the fourth largest grape-growing state.
PHOTO BY DENNIS COX

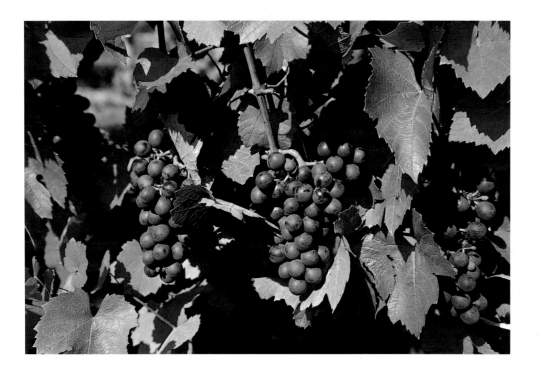

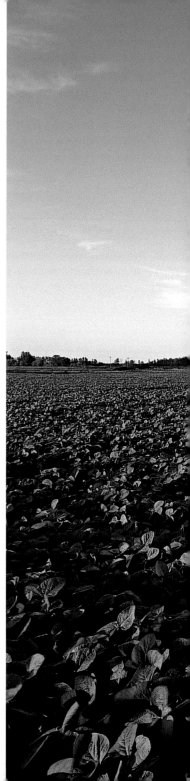

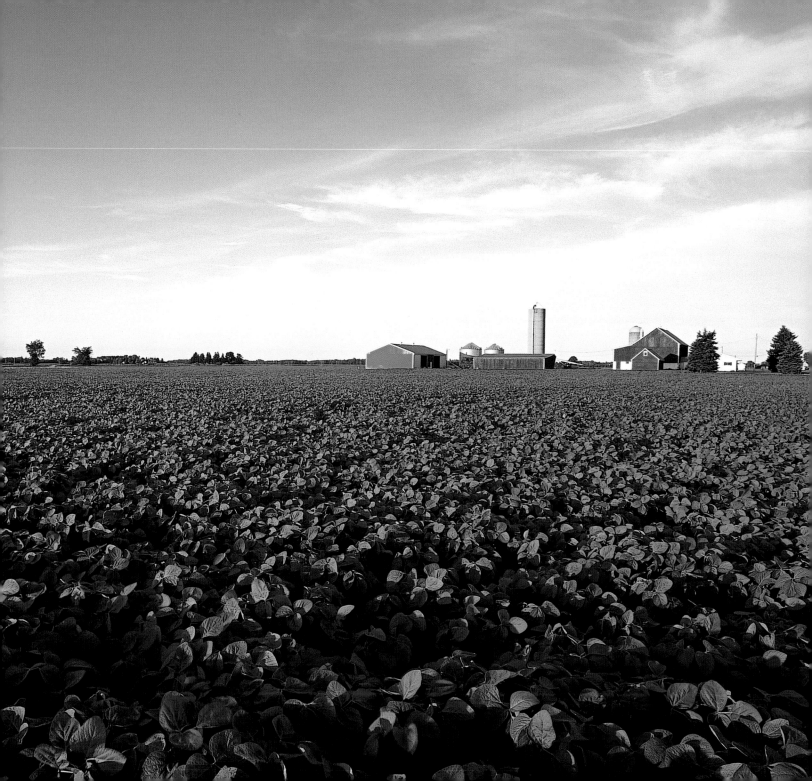

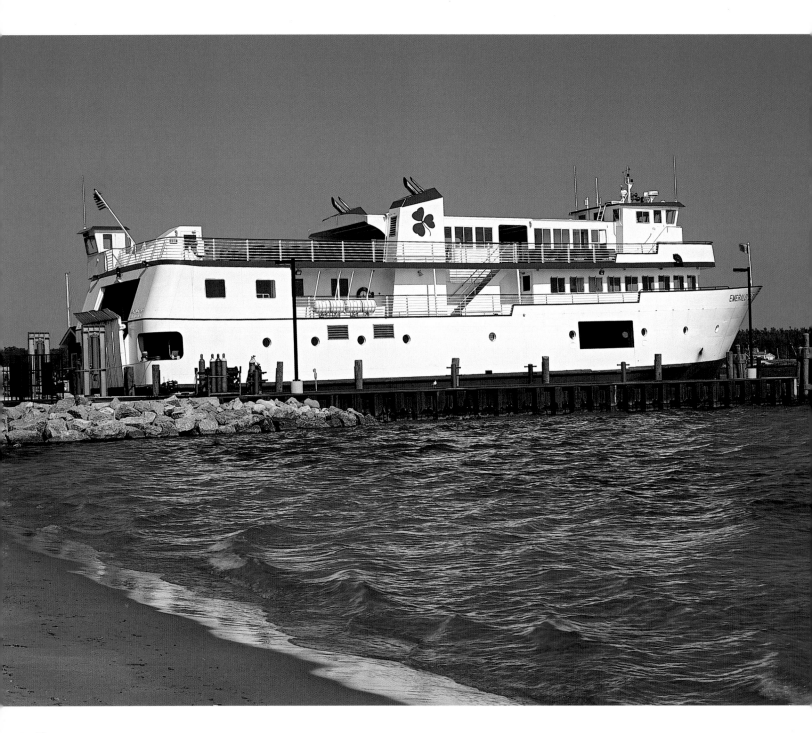

LEFT: The ferry *Emerald Isle* services Lake Michigan's Beaver Island, the most remote inhabited island in the Great Lakes.

BELOW: Sunbathers gather on Ludington Beach near Ludington North Pierhead Light on Lake Michigan.

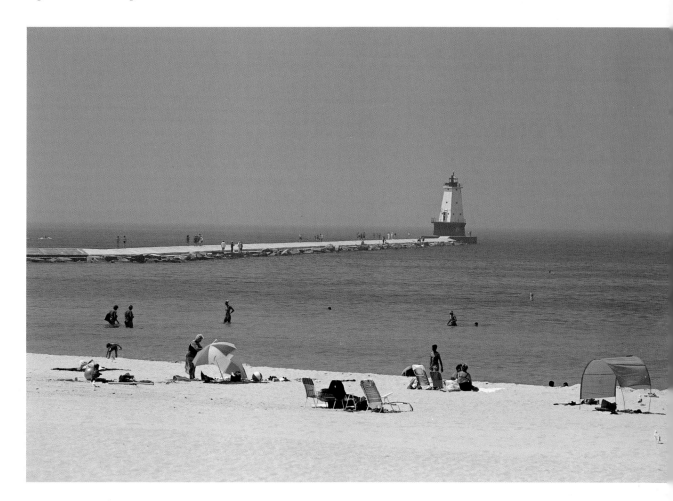

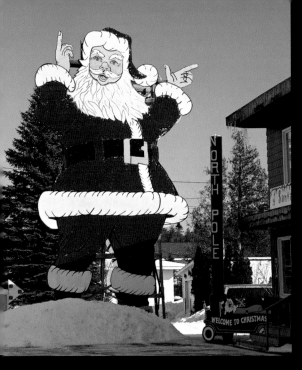

LEFT: A giant Santa Claus points the way to Santa's Workshop, a gift shop in Christmas, Michigan.

FACING PAGE: Silver Lake Channel winds through Silver Lake State Park, which occupies 3,000 acres along Lake Michigan.

BELOW: Magnolias bloom despite a late-spring snowfall at Hidden Lake Gardens in Lenawee County.

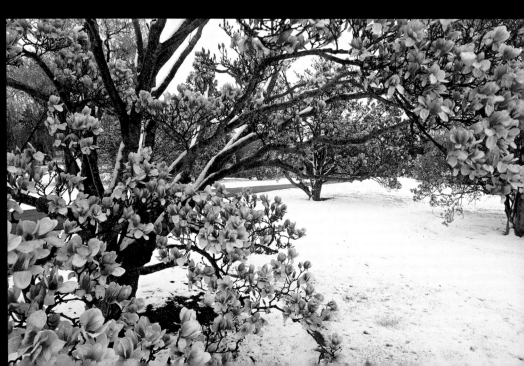

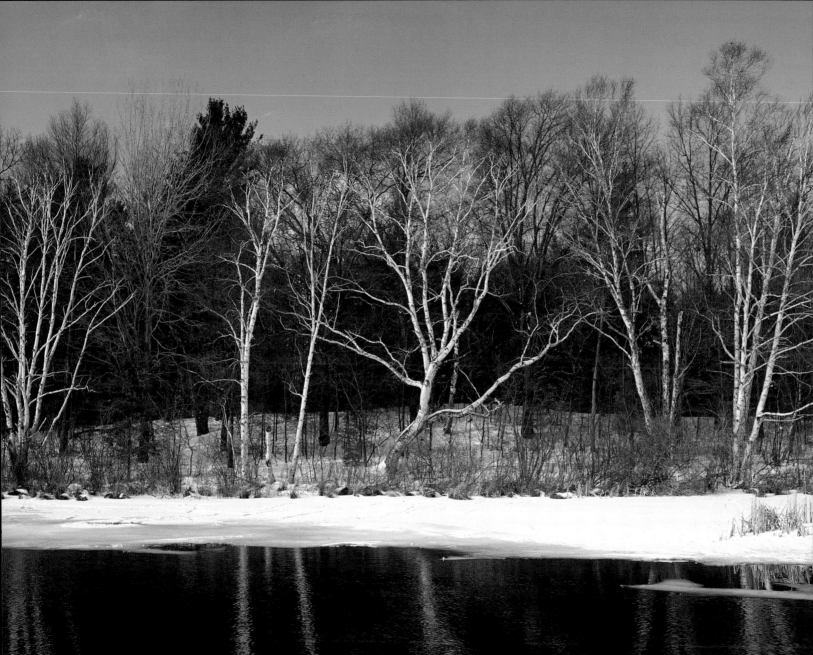

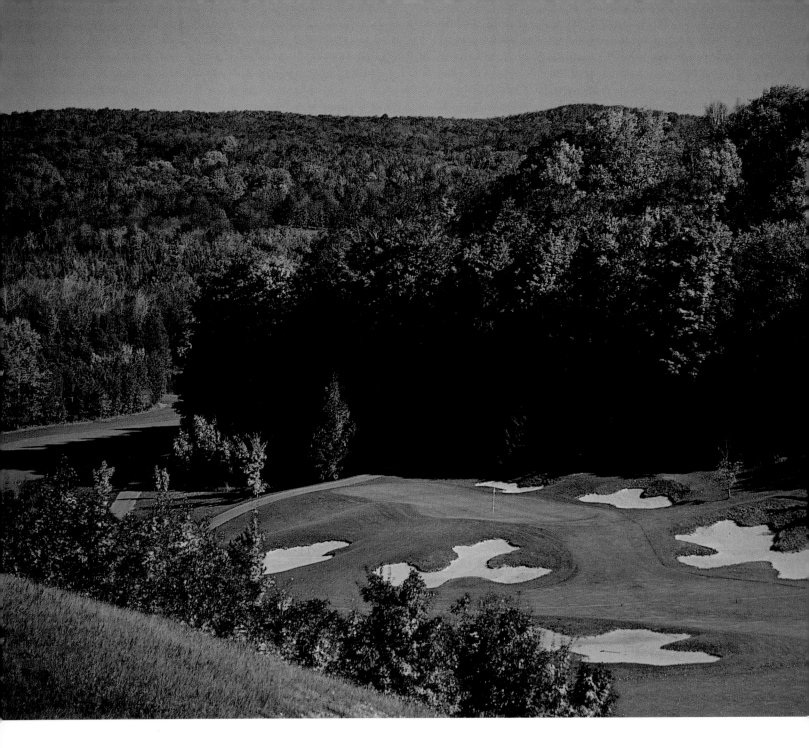

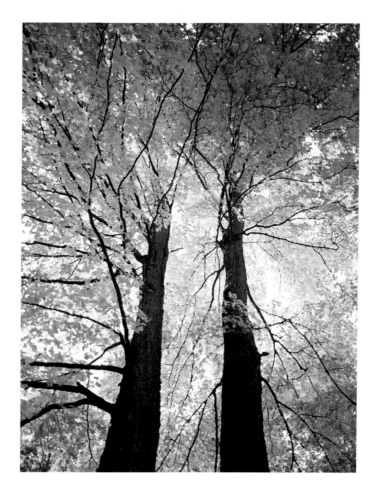

ABOVE: Twin sugar maples show off their fall finery in Mish-a-Mish Park in Copemish.

LEFT: A sea of fall color surrounds the fifteenth hole at Treetops Sylvan Resort near Gaylord. PHOTO BY DENNIS COX

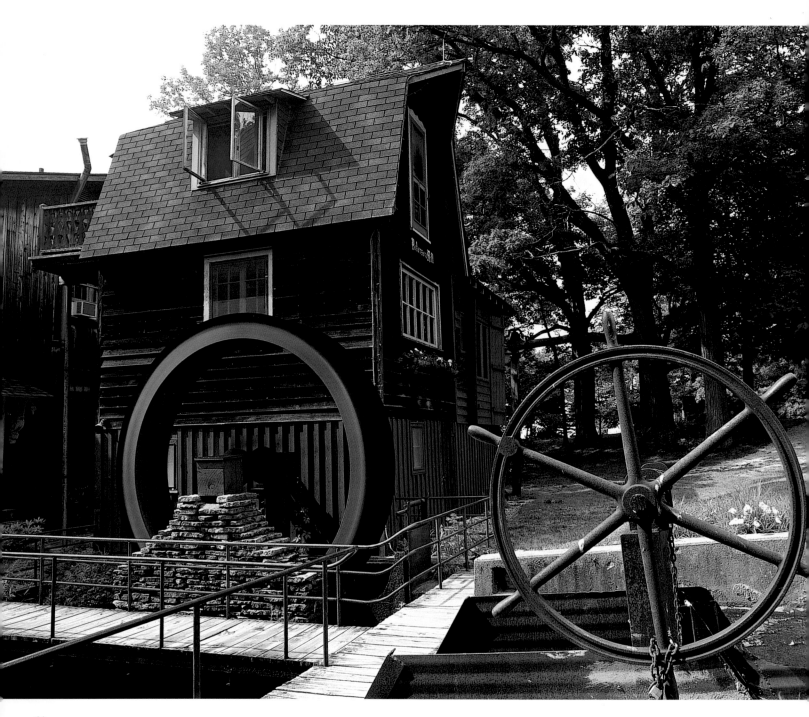

LEFT: One of the most photographed mills in Michigan, Peterson's Mill sits along Moore's Creek in the harbor village of Saugatuck.

BELOW LEFT: The Sojourner Truth Monument in Battle Creek honors the life and work of Sojourner Truth, born Isabella Bomefree (later spelled Baumfree). Born in approximately 1797 in New York, Isabella changed her name to Sojourner Truth in 1843 because she said she wanted to travel the land telling the truth. She spoke about the rights of former slaves, equality for women, humane treatment of the poor, and other issues. PHOTO BY DENNIS COX

BELOW RIGHT: This 24-foot bronze horse is a replica of a large sculpture designed by Leonardo da Vinci that was never completed. It now stands in Frederik Meijer Gardens and Sculpture Park in Grand Rapids. PHOTO BY DENNIS COX

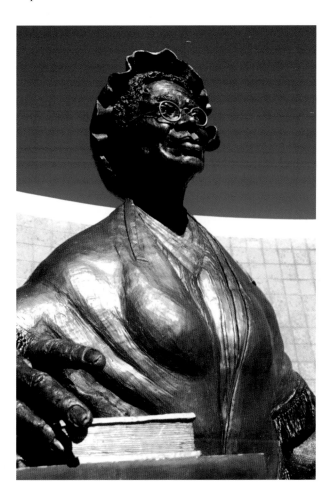

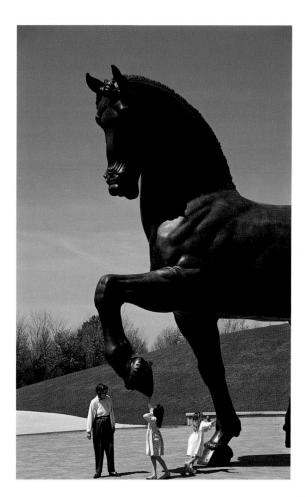

RIGHT: Following a fire, aptly named fireweed thrives. It prefers sunny locations in which the soil recently has been disturbed.

FAR RIGHT: Opened in 1887, the Grand Hotel on Mackinac Island features the world's longest front porch. In 1895, Mark Twain lectured in the Grand Hotel Casino. The movies *This Time For Keeps* and *Somewhere In Time* were filmed here.

PHOTO BY DENNIS COX

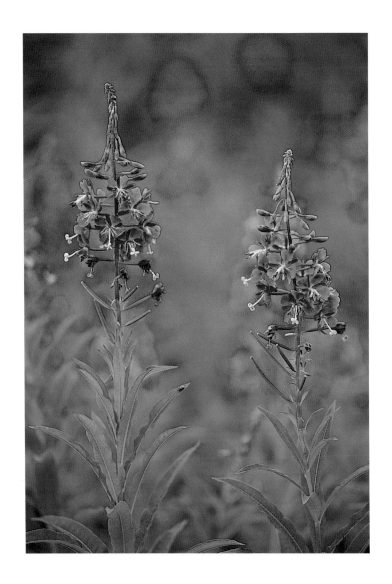

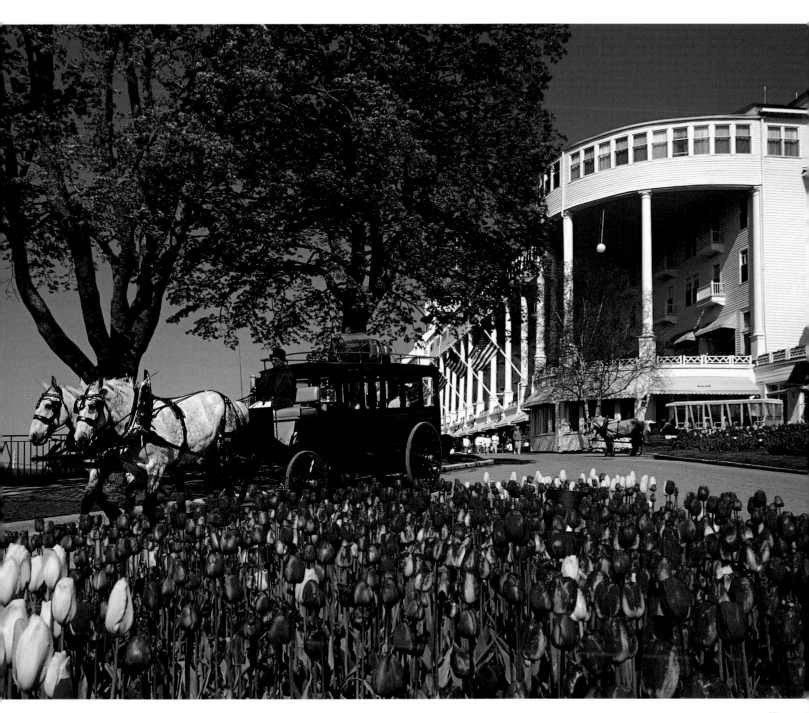

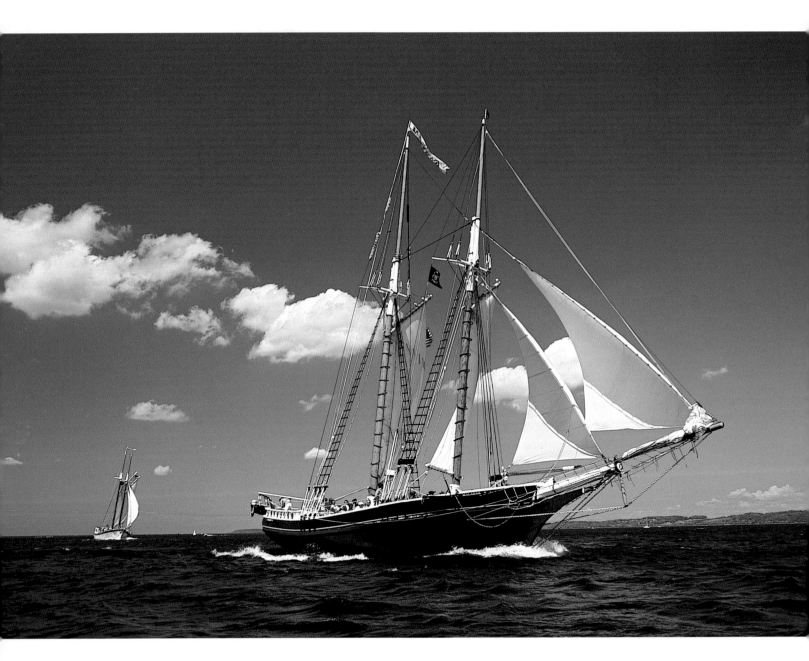

Tall ships sail through Lake Michigan near North and South Manitou Islands.

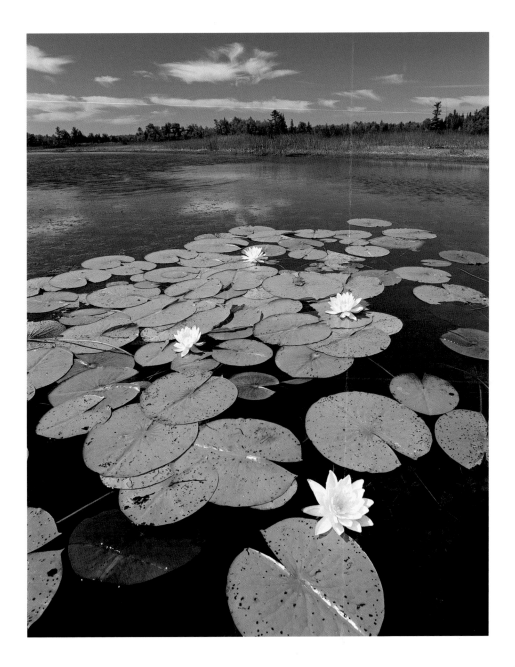

Water lilies spread across a pond near Devils Lake in Alpena County.

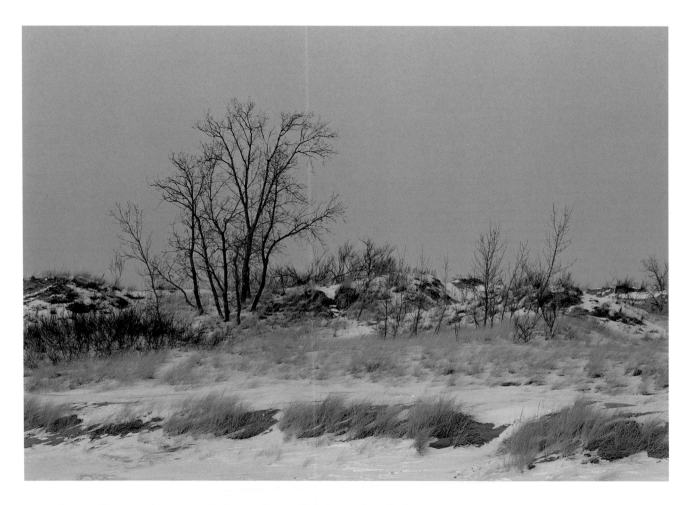

ABOVE: Snow collects on the grassy, windswept dunes of Muskegon State Park.

FACING PAGE: Sunrise paints the frozen expanse of Lake Huron at Forty Mile Point in Presque Isle County.

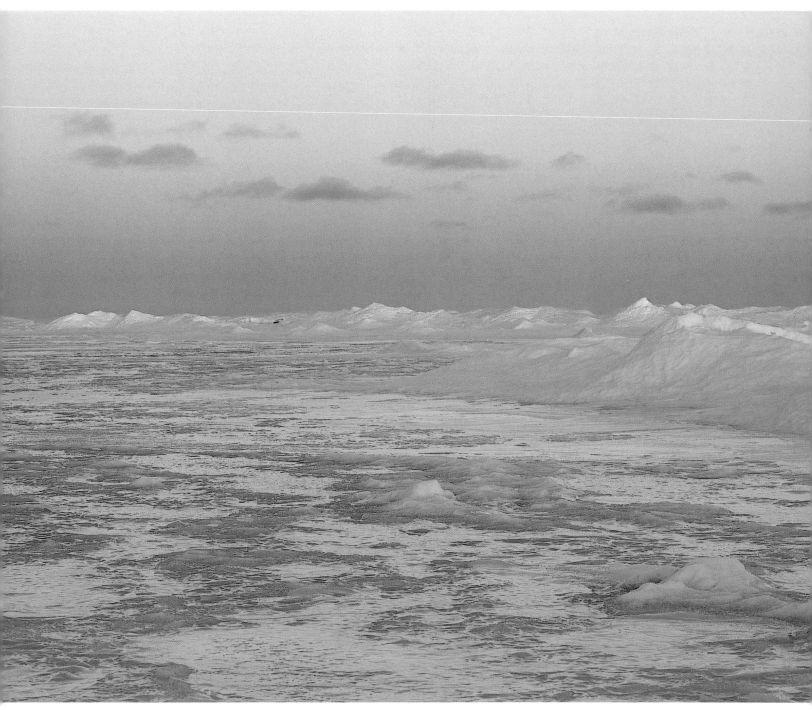

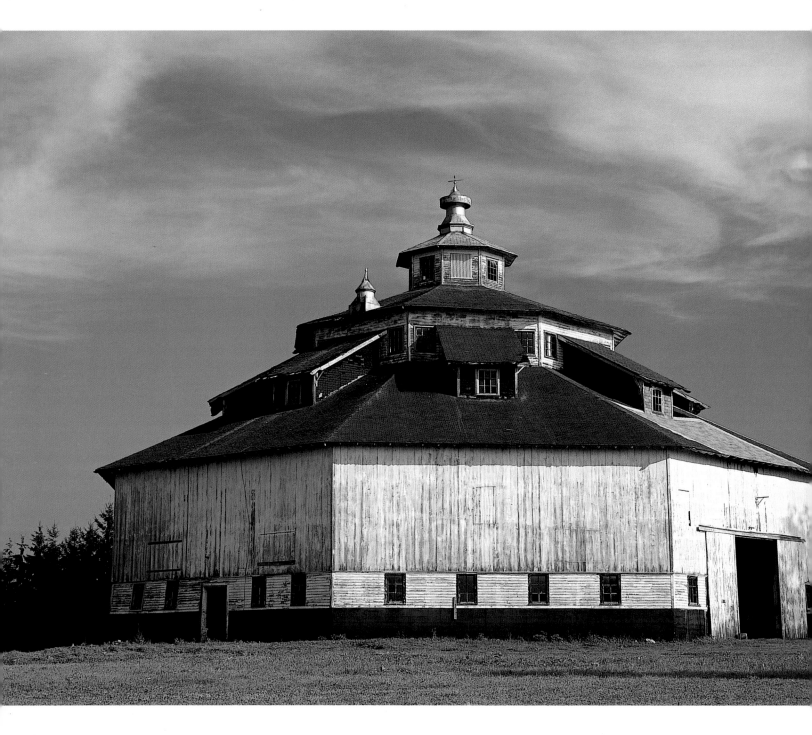

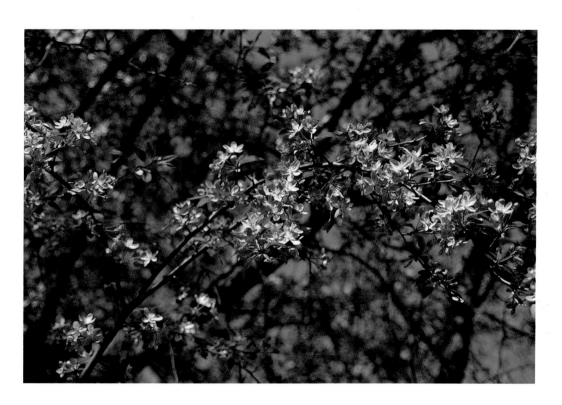

ABOVE: The official state flower of Michigan is the apple blossom. PHOTO BY DENNIS COX

LEFT: In 1924, when this octagonal barn in Tuscola County was completed, its design was considered efficient and progressive and the structure was featured in a 1925 edition of *American Builder* magazine.

RIGHT: The freighter *Buffalo* leaves St. Joseph Harbor on Lake Michigan.

FACING PAGE: The historic Fox Theater in Detroit was built in 1928 by William Fox. The theater is noted for its exotic Hindu-Siamese-Byzantine interior design and is a symbol of the golden age of the movie palace.

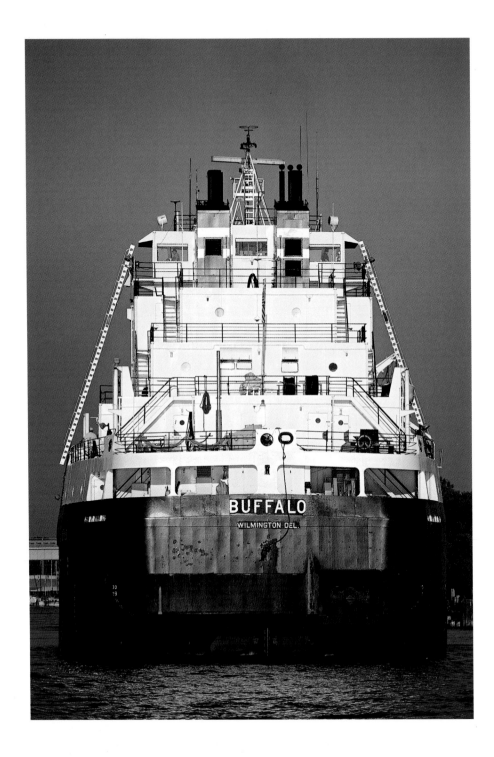

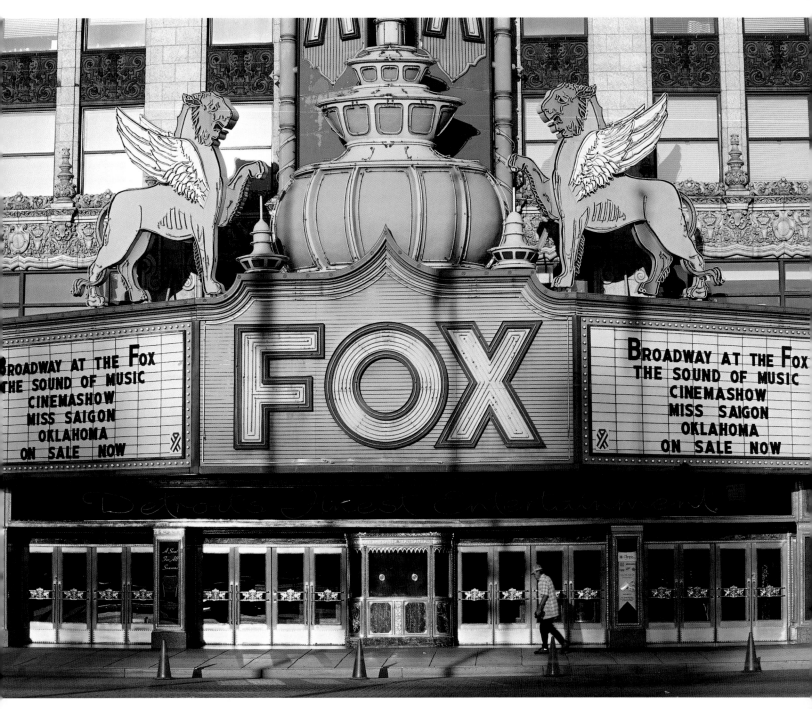

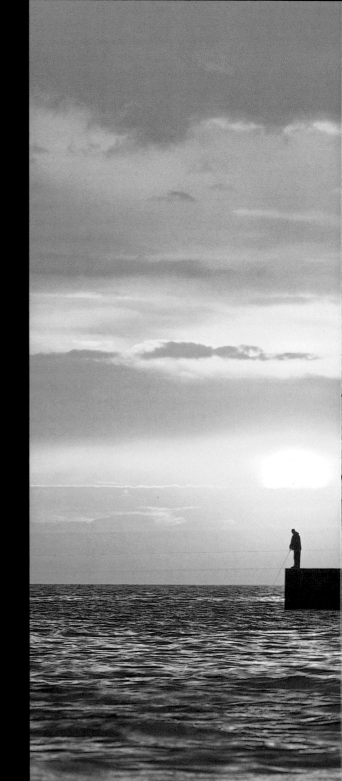

Anglers fish at the South Haven Pier
Lighthouse on Lake Michigan at sunset.

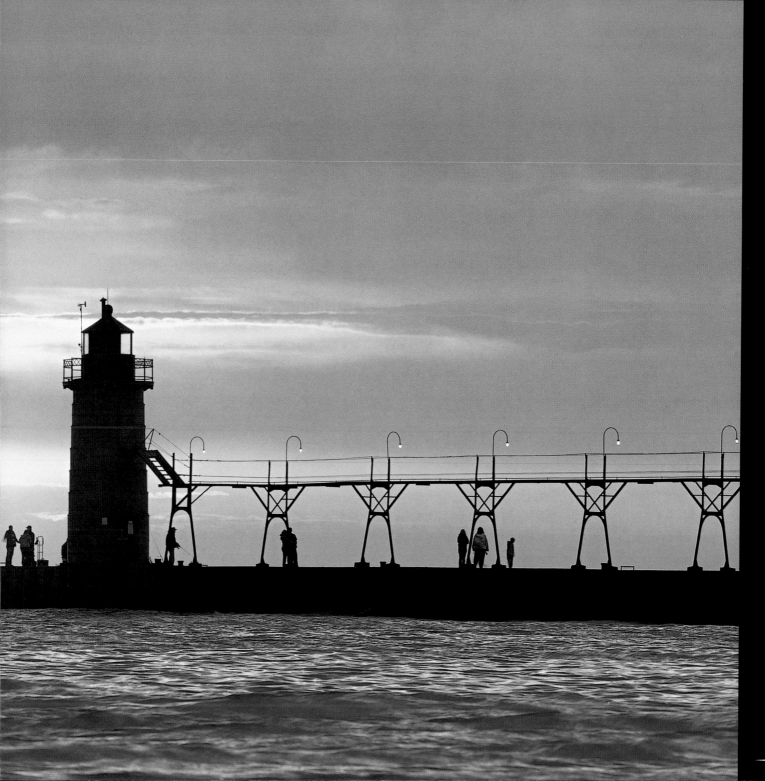

Darryl R. Beers

Darryl R. Beers was raised with a deep appreciation for the natural world that continues to shape his approach to photography. His images have received several regional, national, and international awards and have been published in numerous magazines, including *National Geographic Traveler, Country, Ducks Unlimited,* and *Sierra Club.* His images have appeared in many books and calendars, including those by such publishers as Abbeville Press, National Audubon Society, BrownTrout Publishers, and Reader's Digest. He was the sole photographer for the books *Wisconsin Impressions* and *The Spirit of Door County* and was a major contributor to *Wisconsin Simply Beautiful* and *Michigan Simply Beautiful.*